Silenced But Determined

Synnachia McQueen Jr.

Copyright © 2019 Synnachia McQueen Jr.
All rights reserved
First Edition

PAGE PUBLISHING, INC.
New York, NY

First originally published by Page Publishing, Inc. 2019

ISBN 978-1-64350-097-3 (Paperback)
ISBN 978-1-64350-098-0 (Digital)

Printed in the United States of America

I want to dedicate this book to a number of very special people that I know. I can't mention everyone here; however, stay tuned for *Determined Revelation*. Anyway, to my higher power up above whom I know that his power has enabled me to survive to tell my story. I truly recognize your presence!

I dedicate this book to my lovely mother, Virginia, and sister, Jackie. My brothers, Tyrone and Dewayne. My many nephews and nieces. My daughters Jessica, Tammie, Ejam, and Semiah.

I want to dedicate this book to my many grand Kids: Tiwaniqua Charlot, LaChasity D. Ridley, Dajonnaise M. Fills, Danielle L. Owens, Destinee M. Jones, Zoey A. Jones, Chloe T. Jones, Jamal O. Olasode, Jamarcus Z. Christmas, Hailey L. Allen, Holly A. Charlot, Haiyden K. Ridley, Dylan D. Brunson, and Traya J. Johnson.

I want to dedicate my book to all those friends and costudents that I came into contact with at Houston Community College (2006–2010), Student Government Association, College Activity Board (thanks to instructor Brenda Walker and manager of Fitness Center, International Student Organization, American and Latin Student Organization), and Texas Southern University (2010–2014). I owe a great deal to many of the students and teachers at Texas Southern University. But I want to give a shout-out to Ms. J. Williams and Ms. Roberts; we appreciate your dedication in teaching excellence. To Mr. Stephone, Texas Southern Collegian Sports Media Department. And Ms. Rosalind Thomas, office manager of the Athletic Department at Texas Southern University.

Contributions to Campaign

At this time I would like to pay homage and tribute to those individuals who believed in me to submit financial donations to assist me in having my book published.

Thanks to Mika, Albert Rodgers, Mrs. Owens, Clyde Owens, Rosalind, Priscilla Owens, Pamela Tucker- Knoxson, Evelyn Smith, Lydia Alston, LuLu, Lagatha Hill Joseph, and the law office of Atty. Timberly J. Davis, Stephen Hughes, and Russell Trahan and Fourth Ward Black.

Finally, I would like to give a shout-out to several of my fellow students from Houston Community College. I was part of the student government organization and nominated as chair to oversee the Fun Fall Festival. This is one of the biggest events ever to take place at HCC. Thanks to my fellow committed and student government members who helped me make the FFF a success. Thanks, Charles Lingerfelt, president of SGA; Fida Moukaddam, vice president; Ken Johnson, parliamentarian; Jerquann Lightbourne, treasurer; Aliya Adilbekova, secretary; Kareem Jones, reporter; and Denny Smith, adviser.

PREFACE

I want to give thanks to the following people for *inspiring* and *motivating* me to write and present a final product of the book *Silenced But Determined*. I want to thank my brother Tyrone McQueen. My brother, you have been my constant friend, contributor, and most importantly, a brother that cares. I want to thank Mr. Denny Smith, former student life coordinator at Houston Community College (man, I couldn't have ever accomplished this without your belief and trust in me). Thanks! I want to thank Dr. William Harmon, former president at Houston Community College for your trust and belief in me. Thanks 100 percent! I want to thank Brandyn Cottingham and Tsalta Baptiste, two young men whom I met while attending Texas Southern University. These two young men inspired me to join them in their plight to create a uniform idea to start and maintain a university garden (initially named Icarus Garden) designed to involve the community as a community garden at Texas Southern University. That idea became a reality. Texas Southern Community Garden! These young men also are committed to assist me in my journey to write this book. I want to give thanks to Stephanie I. Hughes, a former co-student and colleague at Houston Community College and Texas Southern University. Imani Hughes has also joined me as part of my team in making our journey of telling my story into a success. I want to thank my attorney and friend, Timberly Davis, who has inspired me for her strength and her dedication to fighting injustices. Atty. Davis is also my attorney and part of my team of loyal people. Thanks, I love you! I want to thank my mental health doctor, Dr. Giovana Zunta-Soares. Dr. Zunta has provided me with positive methods to coping with the continued inducement of pain and mental illness. *Thanks!* I want to thank Timothy Edgin, who assisted me

with creating my web page, YouTube channel, and completed technical operations on my computer. Tim has also agreed to accept my team. I want to give my thanks to Ribian Riza, the great artist who has agreed to work with me on making my book and story a success. Finally, I want to thank a great successful young man in his own life, Russell Westbrook of the Oklahoma Thunder. I initially wrote this book in 2003, when I was paralyzed from the waist down. I had previously tried to get my book published, so I took another journey. However, one night I was watching Russell Westbrook playing against the Houston Rockets, and I could not imagine that he was averaging a triple-double for the early part of the season. However, after watching him play, I realized that Russell Westbrook will go down in history as a top five player of all time. I can't wait to see a better RW this upcoming basket season. *So* I had watched the Big O (Oscar Robinson of the Washington Bullets) average a triple-double almost four decades ago. The ability to average a triple-double through a grueling eighty-two-game schedule seemed like a feat that would never be duplicated. However, to watch RW score, rebound, and assist on a consistent eighty-two-game schedule is super human. So due to the supreme human basketball player and great and down-to-earth person that he is, I became so compelled to have this book published with the intention to push the envelope to be relevant on my terms. Thank you, brother Russell, you are truly family. I want to thank Mrs. Grant and her son Warren, the Grant family. You are very special people. May God truly bless you.

Serious notation: It was very hard to write this book. Actually, this is the main reason for the delay. I fear the following factors: retribution by city, state, and county officials. I feel as though I am torn into little pieces. Shame, a loss for respect, the truth turned into a lie and used against me. I strongly believe that my family and I could be in danger for exposing those whom I've mentioned herein. However, my belief in my *higher power* has given me the strength and courage to accomplish this feat. Like I said, stay tuned for book two. Be blessed!

CHAPTER 1

Silenced But Determined

Today is January 17, 2017, three days before the 2016 inauguration. After almost fourteen years without writing (my beginning date on February 27, 2003, ending on April, 2003), I now begin to reflect on a litany of events to bring us to January 17, 2017.

Today is February 27, 2003, and I am lying in a hospital (prison infirmary) bed. Today, I received another rejection to the latest challenge(s) of my illegal criminal conviction. This latest rejection came from the Texas Court of Criminal Appeals in Austin, Texas. The Texas Court of Criminal Appeals refused to review my habeas corpus petition (Habeas corpus means to release the body, in regard to myself, release me from prison due to unconstitutionality issues that caused my confinement. Up until this point I believe that I had filed at least twelve challenges via habeas corpus petitions.) to the 232nd District Court, Harris County, and the final review being the Texas Court of Criminal Appeals. My latest challenge to the legality of my conviction stemmed from my filing a habeas corpus petition alleging that I had been deprived of the opportunity to prove my innocence via DNA testing. Due to the fact that officials from the Houston Police Department (HPD) Crime Lab had failed to properly tag and file the evidence (victim's panties, panty hose, dress, and rape kit) from my criminal trial with the HPD Crime Lab. Additionally, due to the failure of the court reporter to file the evidence (victim's panties, panty hose, dress, and rape kit) from my trial with the district clerk's office subsequently after my trial, so this evidence could have been warehoused and stored for future use. Therefore, due to the

aforementioned, I contended that those officials (Houston Police Department Crime Lab, Houston police, court reporter from the 232nd District Court and the Harris County District Clerk's Office) had failed to follow proper procedures in ensuring that the evidence from my trial was stored and properly tagged in the Houston Police Department Crime Lab; my request to seek relief via DNA testing had deprived me of the opportunity to prove my innocence. However, those contentions were denied relying on the mishaps of the HPD, court reporter, and district clerk.

The denials of my attempt to prove my innocence have become so numerous to the point that I believe that I have become immune. However, I've always vowed to continue my fight. I came to the realization that my opportunities for fighting the legality of my conviction and subsequently winning my freedom were a faraway dream that would never transpire.

CHAPTER 2

American Injustice Criminal Justice System

So on this day (February 27, 2003), I decided to write a book about the twenty-three-plus years that I have been deprived of the opportunity to prove my innocence. I honestly believe that the evidence is available to clearly prove serious doubt about my conviction. That coupled with the fact that anyone reading the facts that I am presenting herein will have to agree that I did not receive a fair and impartial trial. Nor have I ever been given the opportunity to have a full and fair review of my contentions to determine whether or not I've previously raised legitimate claims pertaining to my trial was conducted void of constitutional protections; whether officials (trial judge, prosecutor, and my court-appointed attorney) conspired to convict me without a fair trial; and most importantly, whether I am actually innocent or not.

The litany of events graphically described herein will be chilling and shocking, which leads me to believe that the pervasive shadow of darkness has obscured the light of fundamental fairness and basic constitutional rights. I thought, at least in theory, which in my case was never quite translated into practice, you were innocent until proven guilty.

What I am actually hoping for, if anything, from writing this book? Actually, I sincerely believe that I am exhausting my First Amendment right to my freedom of speech. And in exercising this right I am speaking out about the injustices that were committed and

continue to be committed against myself. Trust me, I don't believe that my experience was an isolated one. I also believe that there were others before and after me who suffered the same exact fate at the hands of those whom we are fooled into believing are there to protect us and uphold the law.

This book will be my voice to apprise those who may become interested in what occurred to me and my fight for justice. For those who may become loyal readers about the litany of events that transpired during and after my trial on December 17, 1979, subsequent appeals and challenges via habeas corpus petitions. And most significantly, the manner in which my request for DNA testing was denied. Reader, also let it be known I am not the only victim in regard to the aforementioned facts leading to an illegal incarceration.

CHAPTER 3

Paralyzed

Back in December 11, 2002, I was taken from a prison unit (Bill Clements Unit in Texas) to Hendricks Hospital in Abilene, Texas, for the purpose of having surgery. On December 12, 2002, surgery was performed on me, and subsequently after surgery, I was paralyzed from the waist down. As a result of the back surgery, I am unable to walk. I also suffer from several other serious physical injuries as a result of the back surgery. In what might appear as another time of despair in my life, I am actually using this period in time as a motivational push to actually accomplish this feat of writing this book.

I am definitely not a person who would be noted with the expertise and knowledge to be able to write a book. However, these writings come from the heart. So who's to say what I may or may not be able to accomplish? Most of the facts from this book will come from my memory. Due to the memory factor, there is the possibility that a few of the events mentioned herein may not have actually occurred on that specific date and time. However, the lack of remembering some things will not taint the accuracy of the events mentioned herein. For the most part, I would say that about 95 percent of the events mentioned herein are true and correct. Some of the names mentioned herein have been changed for personal reasons and liability issues. Additional facts will be obtained from court records, pleadings that I've previously filed with the courts, answers and responses to those pleadings filed by the Harris District Attorney's Office.

Before I begin writing this book and get to the heart of the matter, I would like to mention a few personal matters, matters of real

importance to my life. I have always felt that if I had the services of a reliable attorney, or possibly that aide of some conspicuous organization(s) (NAACP, ACLU, and possibly the Urban League), or even some type of media attention pertaining to what transpired during and after my trial that I would have been a free man a long time ago. But faith has not been on my side. One personal matter that has really crippled me throughout this entire ordeal is the fact that as long as I have been in prison (twenty-three years and almost four months) I have never had the opportunity to see my three daughters, my mother, two brothers, and my two sisters (one biological and the other adopted).

CHAPTER 4

Who I Was Before My Imprisonment

Let me also mention a few things about myself. On the date of my arrest (September 29, 1979), I was twenty-two years old for thirteen days. And my early life wasn't all that noteworthy. But it wasn't a bad life either. I wasn't raised by my parents. I was raised by friends of my father. The lady and man who I thought were my father and mother, that is, until I reached the age of fourteen, treated me like I was their own son. Raised along with me was this girl who I had always thought was my biological sister, until the revelations when I turned fourteen, was also not a child of the people who we thought were our parents. I was raised in the Fourth, Fifth, and later on in my life in Third wards in Houston, Texas. My life was not one of poverty. As a matter of fact, we lived a life of what I believed to be middle class in the sixties and seventies. During that period, we lived in a very comfortable house with air conditioner, telephones, and televisions. We eventually moved to a very big two-story house during the time that I attended high school. I was a typical kid. I loved all kinds of sports. I participated in football, basketball, baseball, volleyball, roller-skating, bowling, golf, tennis, and swimming. Basically all of my time in school, that is, grade school, high school, and senior high, I consistently was an As and Bs student. I really enjoyed going to school. I can recall when I was in the fifth grade, our fifth grade teacher would pick a student to dust erasers and clean the blackboard after school. However, he would pick the student who would ask him

first. That meant getting to him first. So each morning at 6:00 a.m., I would walk down to the main street where I knew Mr. Henderson (that's the name of my fifth grade teacher) would be driving on his way to school, and I would wait there until he came by, and I would flag him down just so I could ask him if I could dust the erasers and clean the blackboard. He would answer yes and proceed to give me a ride to school. On the way he would pick up Roosevelt, who was my competition in getting to Mr. Henderson first to ask him about doing the erasers. The mystery behind the dusting the erasers was that Mr. Henderson would allow the person whom he assigned to dust the erasers to leave class thirty minutes earlier to go outside to dust the erasers. Well, there would be sometimes be two or three people dusting the erasers, and usually as the school year came to an end, Mr. Henderson only would allow one student. The fun was that we would go all over the school (on the recreation yard, cafeteria, library, down the hallways, you name it, just about everywhere on the school ground we would venture).

When I was in the fourth grade, I had this teacher by the name of Mrs. Roberts, and I totally disliked this lady. She was always on my case about my attitude. My report card would reflect As and Bs in English, math, spelling, and reading. But in regard to my conduct, Mrs. Roberts would give me an F. Now we were supposed to be graded with an S for satisfactory or a U for unsatisfactory. But Mrs. Roberts would say that my attitude was so bad that she just had to give me an F. And this F would always taint the other accomplishments that I had made in class. However, actually it was my attitude that tainted my success in class. Mrs. Roberts was giving me my first lesson on changing. I didn't per se felt as though I had a bad attitude. I would not listen, but my crime was just being the class clown on too many occasions. Many times I was doing some type of stunt for a laugh and attention from my classmates. And the responses were usually one where all the students did laugh at my antics. Mrs. Roberts was irked by this.

CHAPTER 5

Growing Up in the Fourth Ward

I attended an all-black school during my elementary school days. I attended Gregory Elementary from elementary to sixth grade. When I reached the seventh grade, I attended Abraham Lincoln High School. This school was newly built and had recently opened when I began the seventh grade. The school was integrated. Lincoln curriculum consisted of grade 7 up to the twelfth grade. I played football, basketball, and I ran track on my first year. Just about everyone at the school I had already knew from our days at Gregory Elementary.

I just loved going to school, and even though I never did make the perfect attendance list, three of the years that I attended Lincoln I only missed one day from school in each year. Actually, this was kind of remarkable in a way due to the fact that two of these years where I missed one day from school I was working for this company called Gulf Coast. We made telephone books at Gulf Coast. I would get out of school at 3:00 p.m. and be at work at around 3:30 p.m., and on most nights I would get off of work at two or three in the morning. I was a quick learner, and I learned how to operate and disassemble the equipment. Our supervisor liked me a lot, and he would teach me everything about the job. He also would call me in regard to operations on our shift on those days that he couldn't come in to work. Most nights he and I would be the only two workers working into the early morning hours cleaning the machines. I also learned how to operate the printing press machine. I had basically worked all

my entire young life. I probably began working at the age of eight or nine. I worked various jobs from throwing newspapers to grocery stores, and cutting grass and cleaning yards.

I was not the perfect child, not by a long shot. I had a few brushes with the law when I was a juvenile. I was arrested when I was caught riding a stolen bicycle. I was also arrested three times for trespassing. On two separate occasions, I was arrested for attempting to sneak into the Houston Coliseum. Every Friday night, we (myself and my friends) would go to the coliseum to watch the wrestling matches. And when we didn't have any money, we would sneak through the side down entrance without paying. Additionally, I was arrested for standing in front of a peep show venue. Each time that I was arrested, I was released on my own. However, subsequently after my arrest for the stolen bike, my foster father had to come and get me out of the juvenile ward on West Dallas.

In the year 1975, during my eleventh grade year in school, I was taking a homemaking class and I had left to go to lunch. Prior to going to lunch, one of my friends asked me to hold on to an ounce of marijuana. I therefore took the marijuana and placed it in my briefcase, and I left my briefcase in the homemaking class. I believe that my homemaker teacher had seen this exchange between myself and my friend Touger. In about thirty minutes later we returned from lunch and I went back to the homemaking class to retrieve my briefcase. Subsequently after I retrieved my briefcase and was heading to my next class, I was met by the high school football coach, Bo Humphrey. Coach Humphrey approached me and informed me that Mr. Piper (high school principal) wanted to speak to me. Coach Humphrey escorted me to the principal's office. I actually didn't think that anything was out of the ordinary that the principal wanted to see me. Not to say that this was a usual situation, whereas the coach was summoning me for the principal. Nevertheless, I proceeded to peacefully follow Coach Humphrey to Mr. Piper's office. Once I reached Mr. Piper's office, he asked me to empty my briefcase. I responded, "For what?" He indicated that he had heard that I had been bringing drugs onto the school campus. Naturally, I denied doing this. But eventually I went ahead and emptied the contents of my briefcase

onto his desk. He asked me what I was doing with the bag of weed. I responded, "I was just holding it for a friend," and it was not mine. He asked me who this person was. I informed him that I could not tell him. The police officer then asked Mr. Piper what type of student was I. Mr. Piper stated that he was actually surprised by this incident; he said because he had previously checked my school records and found out that I was a constant A and B student without any prior bad behavioral reports. The police officer then asked Mr. Piper how long it would be before I graduated from school. Mr. Piper said, "It would be next year, if I continued at my current rate in my classes."

The police officer next said something that really surprised me. He stated to Mr. Piper, "I don't see no need in taking this student to jail, a student that is a good student and who will be graduating next year." The police officer went on to say, "I'll just take the bag of dope and dispose of it, and we'll forget that this matter even happened." But Mr. Piper wasn't having any of that; he told the officer that he reported this matter to the police officer and he wanted him to arrest me. The police officer asked Mr. Piper if he had any children. Mr. Piper said yes. I interjected that his children went to Lincoln also, and I knew his daughter and son very well. The policeman told Mr. Piper to look at me as though I was one of his children. Mr. Piper retorted, "I am under a great deal of pressure from school board members to clean this school up, and making sure that he is taken to jail for possessing drugs on my campus is the right way to handle this matter." Mr. Piper stated, "So, if you are refusing to arrest him, I will have to report you to your superiors."

The police officer relented and instructed me to go to his patrol car outside. Once we reached his patrol car, he didn't even handcuff me, and then he told me to sit in the front seat. While we were en route to the police station, we passed by my girlfriend's house, who had my two-year-old daughter. I begged the police officer to let me go. The policeman told me that he really wished that he could, then he said that Mr. Piper would probably call the police station to find out whether or not he had brought me in. So the policeman said that he had no other choice. I was eventually charged with misdemeanor

possession of drugs and placed on one-year probation. I successfully completed the probation.

Honestly, the marijuana was not mine. It was a friend of mine, but I could not give him up. The irony of the whole thing was that I had just started smoking weed about a week before this occurred.

Later on, I came to find out that Mr. Piper had been in the newspapers previously for stealing the school's (Abraham Lincoln) money, and he was under investigation for this crime during the time I was in his office in regard to my possession of the weed. After I became aware of this fact, I believed that Mr. Piper used my situation as a method to attempt to clean up his image at the school.

After this incident, I basically dropped out of school. Mr. Piper made requirements before I could return to Abraham Lincoln. Those requirements were that I had to attend drug counseling classes during the summer and prior to my being considered to be allowed to re-enroll at Lincoln. In 1976, the year that I should have been graduating from Abraham Lincoln, I registered at Jack Yates High School in the Third Ward area. However, I never did get back into the groove of liking school anymore. I therefore dropped out of school and found a job. Plus, I had a daughter to care of.

Chapter 6

Going into Adulthood (Becoming a Man)

After working several jobs, I made the decision to go to the military and get married to my daughter's mother. I therefore applied to go to the Army. I was assigned to two black men, recruiters, and they discussed the process, the military, and the Army in particular, due to the fact that my decision was to go to the Army. In any event, they prepped me for the level entry exam. Basically, they just suggested that I study certain subjects. In any event, I took my scheduled exam almost thirty days after my decision to enter the military. Prior to taking my exam, I spoke briefly to my two recruiters. They wished me luck and gave me a lot of encouragement.

Several days or maybe a couple weeks thereafter (long time ago, I can't actually recall the exact date), I was contacted by my recruiter, and one of the recruiters informed me that the test results were in. He asked me to come to the office (downtown Houston Military Registration Office). After catching two buses and walking about ten blocks, I arrived at the recruiters' office. However, when I got there, both recruiters were there. I entered the office; both recruiters stood up to shake my hand and congratulated me. The recruiters informed me that not only had I passed, but I made the top five score in my recruiting class. Additionally, the recruiters informed me that I had to take the physical and once I passed the physical, I would go to boot camp for eight weeks. Subsequently after my stay in boot camp, I would leave being an E6. My recruiters informed me that this was

the equivalent to a staff sergeant. They informed me that this was possible due to the top five score that I had made on the level entry exam. My recruiters gave me the paperwork to take the physical. About a week later, I was examined by a military doctor (medical); during my examination with this doctor, he examined me from head to toe. Once he looked in my right eye with a light, he asked me what happened to my right eye. I informed him that when I was about five years old, I was hammering on a wooden chair when a piece of the stick broke off and struck me in my eye. My vision in my right eye was 20/30. Once the doctor reached my back area, he informed me that I had a curved spinal cord. I informed the doctor that I didn't know that and the fact that I had never had any problems with my back.

The military doctor informed me that he was denying my physical, indicating that I did not pass. I asked the military doctor why he was doing that. He indicated that I have an S curve in my spinal area of my lower back, and I had glaucoma. The military doctor informed me that due to his decision to fail me on my physical that I would not be allowed to enter the military. I was devastated. I asked him how he could fail me. I indicated that I had been an athlete all my life, plus I had always been able to work hard in my life without having any physical problems. The military doctor showed me some type of chart demonstrating if a person had the two medical problems that I had were to be failed on the physical exam. I was devastated even more when I had to give the news to my recruiters. They were very disappointed. They informed me that it was nothing that I could do and they wished me luck.

In 1978, I was arrested for driving a stolen vehicle. I was joyriding in a stolen vehicle with two other friends. I took the rap, and my friends were released. I received a four-year probation for the unauthorized use of a motor vehicle.

Reflecting back even further, another eventful occurrence happened to me. At the age of fourteen, and subsequently after my foster mother had passed away, my fine foster father told me and my foster sister that we were not their real children. He told us the names of our real parents. Well, in my case he told me who my real father was,

but he also told me that he did not know my real mother. For many years prior to this revelation, I had already knew my real father. I just didn't know him as my real father. He would always come and see me from time to time (once a month) from the time that I was six years old. At least that's where I can actually recall seeing him. But my foster parents and my real father had always told me that my real father was my godfather. I didn't have any feelings after I received this information. Maybe because I never did feel all that close to my foster father at all. I was very close to my foster mother. Things really changed after these revelations and after my foster mother's death. My foster father didn't seem to care that much about us anymore. So I did what was necessary to start taking care of myself. I still saw my real father very infrequently. He eventually told me about my real mother, who was still living with three more children. One day he picked me up and took me over to my maternal grandmother's house to see my mother. However, she wasn't there. Nevertheless, two of my aunts and my grandmother were there, and I got the opportunity to meet all of them. It was very nice and comfortable. One year after my foster mother passed away, my foster sister ran away from our home.

In 1977, at the age of nineteen, I moved out on my own. I moved around from different apartment to different apartment. I shared some of those apartments with several friends and later with several girlfriends. But for the most part I lived alone. During this period in time I held several different jobs (construction, warehouse, clerk, and fast food restaurants). In 1978, my big break came when I was hired to work at Carnation Milk Company. I just loved my job. I started off working inside the refrigerator vault, where we would load paper cartons and plastic jugs of milk, juices, and other dairy products onto Safeway trucks.

I eventually progressed in the company rapidly. I learned how to do basically every job at the company. My main job during the time of my arrest was to unload empty milk crates off the Safeway trucks. This is what everyone was calling the best job at the plant. Nevertheless, I had worked hard and worked my way up the ranks. Most of the time, there wasn't much work for us to do. Two of us worked the line as what we called it. A conveyor belt where we would

load empty milk crates off trucks onto the conveyor belt and the crates would travel onto the docks, where my coworker (one time my best friend was working with me) would take the milk crates off the line and line the crates up on the dock. However, I did spend a lot of time on my job going into other departments and helping them out. As a result of the assistance that I was providing to other departments, I was accumulating many hours of overtime. At the age of twenty-one, I was the youngest employee at the company and I was the next person in line for the foreman job. Increase in pay and supervision, plus as a foreman I could still accumulate many hours of overtime.

In 1978, I had a two-year-old daughter whom I loved and adored with all my heart. Her name is Jessica Marie Graves. In 1979, I also became the father to two baby girls, Tammie, born on March 1, 1979, and Ejama, born on July 8, 1979.

All of my daughters were born to different mothers. They were illegitimate. I admit that at this age I was very irresponsible as far as having children goes. I thought that it was more like a game than something of lifelong experience importance. Don't get the wrong impression. I did in fact provide for my daughters. I was just irresponsible when it came to having children. I admit that I may not have been the perfect poster boy. I could have never been the type of person who went out and raped and robbed women. I didn't have any outstanding debts. I was not being pressured to take care of my daughters. I lived in a nice apartment, and I was saving my money for a new car and other things.

In 1984, I made contact with my mother. My paternal aunt gave me my mother's address, and for the first time in my life I'd made contact with my mother. I was in prison when this occurred. I had this very strange feeling. I can't quite explain it in words; however, I did not feel love. Over the years prior to this writing, we've communicated via correspondence. Nevertheless, to the date of this writing, I still haven't met my mother personally. During the year of 2000, I found out that my mother also had two more sons and a daughter. My maternal brothers and sister. How I found out is a very long story, but I will say that my mother never told me that she had

two more sons and a daughter. During the year 2001, I received a letter from my two nephews (Tyrone McQueen Jr. and James Jackson). These young men were around seventeen or eighteen, and they asked me who I was. They stated that they had found my letters under their grandmother, my mother's bed. So they decided to write to me without her knowledge. We exchanged several letters. In the year 2002, I received one letter and a picture from my brother Tyrone McQueen. As of the date of this writing, I have never met my brothers and sister personally.

As of February 2003, I have never met my daughters personally. However, over the years (1980–2003) via correspondence I have a relationship with my daughters Jessica and Tammie. I have never had any contact with my daughter Ejama.

Chapter 7

Prison Life

Prison life has been very hard on me. I currently suffer from severe depression and anxiety. I have watched the years slowly pass me by as though I am waiting my time to die. I clearly was defiant to prison rules, regulations, and procedures. I clearly did not want to associate myself with the prisoners, especially not the guards. Once my appeal came back affirmed in the 1982, I decided that I would no longer work, nor would I continue to participate in what I saw to be a legalized way to conduct slavery. I clearly refused to abide by any rules that I believed was harming myself and others.

For twenty of the twenty-four years of my incarceration I was confined to administrative segregation (prison in prison), one of the most inhumane and cruel confinement facilities known to man, and I was there for twenty years. Once I realized that the prison system was so full of corruption, discriminatory housing, workforce, and procedures and policies that were very adverse against black men. I decided to arm myself with a potent weapon. Knowledge and comprehension of the laws of the land. My many fights with prison officials will be documented in *Determined Revelation*, coming soon. Funny thing though, I have never contemplated killing myself. I believe that if I was to somehow fall dead or even kill myself, I would lose my fight to prove that my conviction was illegally obtained in gross violation of my United States and Texas constitutional rights. Therefore, I trek onward.

I thank everyone that commits him/herself to write a troubling and fascinating story. Please make your own conclusions. Don't close your mind to what systematic racism really is.

CHAPTER 8

For 23 Years and 348 Days of My Life, I Lived a Nightmare

On September 29, 1979, at approximately 6:30 a.m., I, Synnachia McQueen Jr., had just left my apartment in Third Ward, Houston, Texas. I was en route to the weed house (place where you can purchase weed) in the separate area close to Third Ward. While en route to the weed house, I noticed a car approaching me at a high rate of speed. As the car got really close to me, I realized that whoever was driving the car was trying to run over me. I immediately ran out of the street and into someone's front yard to avoid being hit by the car. The car sped on by with the driver hollering out expletives at me. I noticed that the driver was a light-skinned black male wearing a hat. I did not know this person.

I proceeded to continue to walk toward the weed house. This was about a mile from where I lived. Once I reached the weed house, I knocked on the door and I was greeted by a white female. I informed her that I wanted to purchase a bag of weed (marijuana). She instructed me to come in and walk to the back of the apartment, which was where the kitchen was located. I had already been to this place on several prior occasions. I proceeded to walk toward the kitchen, and once I entered the kitchen I was greeted by this white guy whom everyone called *Red*. There was another white girl and a

black guy sitting at the kitchen table. I informed Red that I wanted to buy an ounce of weed. Red walked over to an ice chest and pulled out a plastic bag of weed. Red tossed the bag to me, and I proceeded to examine the contents. I looked over the contents inside the bag, and I also smelled it.

Red stated, "Man, this is some good shit, I just got this in last night."

I said, "Yeah, man, it looks and smells damn good."

Red said, "Man, we are smoking some of it now." He asked me if I wanted to try some out by smoking with them.

I said, "Yeah, man, that would be right on."

Red told me to have a seat at the kitchen table. He spread about three or four ounces of weed and a weed pipe on the kitchen table. Red tossed me a weed square, and I lit it up. Subsequently after I had smoked the entire joint, I said to Red, "Man, this is some damn good shit." I then asked, "What do you want for the bag?"

Red stated, "Give me a thirty spot" (meaning thirty dollars). I handed Red a twenty- and a ten-dollar bill. I stayed at the weed house for about another hour smoking weed and talking to Red and the other two individuals in the room. During our conversation, I told Red and the other people about the individual who had attempted to run me over during my walk to his house.

After about an hour, I left Red's house and began walking back to my apartment. While en route to my apartment I was approached by a Houston Police Department officer driving a police vehicle. Also inside this vehicle was the guy (later was revealed to be Mrs. Malveaux's husband) who had earlier attempted to run me over. The police vehicle was about twenty to thirty feet from me when someone yelled from the police vehicle for me to stop. As I turned to look at the police vehicle, the light-skinned black male jumped out of the passenger side of the police car and began heading in my direction at a fast pace.

About a split second later, a policeman jumped out of the driver's side of the car. The policeman hollered for me to stop. The light-skinned black male began running toward me. I turned around and began running. I ran through several alleys between houses, and I

was able to elude the policeman and the other guy. But I noticed another police car driving toward me, so I began running again. I was making an attempt to get to my apartment, which was only about eight or nine blocks away. To get out of sight of the other policeman that was driving the police car that was heading toward me, I proceeded to run inside a garage where I began hiding. I could see out of the window of the garage two policemen were just outside the garage looking around the garage and looking around the parameter of a house, which was adjacent to the garage that I was hiding in. As I noticed one of the policeman getting close to the entrance of the garage, I subsequently ran out of a side door of the garage. I did not see no one at this time, so I took off in a fast trot. After I had walked another half a block, another car with two policemen pulled up alongside of me and one of the policemen ordered me to stop. I just took off running again. Both policemen exited the car and began chasing me. I was able to put a little daylight between myself and the policemen by running around two houses and a picket fence. However, I was rapidly running out of gas. On my possession I still had the bag of weed on me. The only thing that I could think about was getting rid of the bag *of weed*. So I pulled the bag of weed out of my pocket and threw it under one of the houses. I at this time saw one of the police officers coming toward me, so I took off running again. However, I was out of gas, so I could only muster up enough strength to run on the side of a building and hide.

Several seconds later, one of the officers came upon me with his gun drawn. This officer ordered me to come out with my hands up in the air. I complied. I subsequently fell on the ground from exhaustion. The officer ordered me to place my hands behind my back. I also complied with this order as well. While this police officer was handcuffing me, the other officer came up to where we were. Subsequently after handcuffing me, the officers lifted me up on my feet and began doing a pat search (searching my body). The officers proceeded to ask me if I had any drugs, weapons, or anything illegal on me. I responded, "I do not." The officers then escorted me to the police car. While walking to the police car, one of the officers asked me why I was running from the police. I told the police officer that

this black guy who had earlier that morning attempted to run over me with his car had just jumped out of the police car and began chasing me. I told the officers that I was frightened.

The officers placed me in the police car and got on the radio. This one officer was talking to someone on the radio stating, "We got suspect in custody and where is your location." The officer on the radio told the officer in the driver's seat "he's over on [he mentioned the name of a particular street that I don't remember]." The officer subsequently drove off until we reached a particular destination where the first officer (who had begun the initial chase of me) and the light-skinned black man were waiting. The officer pulled up beside the police car and asked the first officer (who began the initial chase) was I the one. The other officer looked inside the vehicle and stated yes. The first officer then motioned for the black guy (who was also a part of the initial chase) to come over to the police car, where I was sitting. The other officer asked the light-skinned black guy if I was the one. He responded yes. I then asked the officer, "Was I the one that done what?" I then stated that this was the same guy who had attempted to run over me with his car earlier that same morning. The officer stated that "he has made a complaint that you robbed and assaulted his wife." I stated, "Man, this dude is crazy. I don't even know him, nor his wife." (As you will find out later, I did in fact know his wife, but not from robbing and assaulting her). The officer in the car told the first officer that they were going to take me downtown to the police station. The first officer then proceeded to drive away with Mr. Malveaux (the name of the light-skinned black guy that gave chase and the husband of my accused victim, Mrs. Malveaux). While en route to the police station, the officer in the passenger seat asked me if I had ever done any robberies in this area. I stated to the officer, "No, I have never done any type of robbery whatsoever." The officer then drove up in front of a store adjacent to a liquor store. The officer in the passenger side got out of the car and went inside the store. Several minutes later, the officer came back with an old white guy trailing behind him. The old white guy came to the side of the police car where I was sitting. He looked inside the car at me. He then looked at the officer and shook his head as if to

say no. The officer got back in the car and the officers proceeded to drive to another location, where another store was. The officer in the passenger seat got out again and went inside the store. Several minutes later, he returned with a middle-aged black man trailing behind him. The black man came to the side of the car where I was sitting, and he looked directly at me. He then looked at the officer and shook his head as if to be saying no also. The officer got back into the car, and the officer proceeded to take me to the downtown police station.

CHAPTER 9

The Police Interview

After we reached the police station, the officers escorted me up to one of the floors in the Houston police station. I was thereafter placed inside a cell with four other people. About an hour later, I was escorted to this room where this detective was seated. Once I entered the room, the detective introduced himself as Detective Gonzales. Detective Gonzales asked me to take a seat, and the officers who had escorted me exited the room. Detective Gonzales asked me if I knew why I was there. I told him, "No, I did not." Detective Gonzales was reading through a file that he had on the table. He asked me if I knew a Mrs. Malveaux. I told him that I did not know a Mrs. Malveaux. Detective Gonzales informed me that Mrs. Malveaux had filed a criminal complaint stating that a person fitting my description had physically assaulted and robbed her on September 27, 1979. I told Detective Gonzales that I had never committed any assault against Mrs. Malveaux, nor did I even know Mrs. Malveaux for that matter.

While I was talking to Detective Gonzales, another detective entered the room. This detective said a few words to Detective Gonzales, and Detective Gonzales introduced this detective as being Detective Williamson. Detective Williamson asked Detective Gonzales what he had so far. Detective Gonzales responded, "Nothing yet, he says that he don't know anything about any assault, robbery, and he says that he does not know Mrs. Malveaux." Detective Williamson told me that he and Detective Gonzales worked the robbery division at the Houston Police Department, and they were investigating a robbery that took place in the area that I was arrested in on September

27. Detective Williamson went on to say that Mrs. Malveaux has given a description of the person whom she said assaulted and robbed her. Detective Williamson said that I fit that description. Detective Williamson additionally stated, "I was informed by the officers who arrested you earlier that Mrs. Malveaux's husband pointed you out as the person that assaulted and robbed his wife." I again told Detective Williamson that I didn't know anything about what he had just mentioned. I additionally told Detective Williamson that the only thing that I knew about Mrs. Malveaux's husband was the fact that he had made an attempt to run over me with his car around six thirty that morning, and when the policeman approached me with his car Mr. Malveaux jumped out of the patrol car and began chasing me; therefore, I took off running.

Detective Williamson asked me, "How long have you had that gold tooth in your mouth?" (I have a gold tooth on one of my front teeth; this gold tooth would be the main basis for my subsequently being charged and convicted with aggravated rape.) I told him that I had the gold tooth for about five or six years. I asked him, "Why do you want to know that?" He told me that with my high cheekbones, light complexion, and gold tooth, along with the area that I was arrested, I fit the description of a rape suspect. I informed the detective that I hadn't participated in raping anyone. Detective Williamson said something to Detective Gonzales and proceeded to walk out of the room.

Several minutes later, Detective Williamson returned to the room with a sketch of a picture. Detective Williamson showed the sketch to Detective Gonzales. Detective Gonzales then turned and looked at me. Detective Williamson stated that I did in fact fit the description of the person in the sketch. Detective Gonzales then asked me if I knew anything about a rape and robbery that had taken place on August 9, 1979, in the same general area that I had been arrested in. I stated, "Man, I don't know anything about any rape and robbery that had taken place on August 9." Detective Williamson then asked me, "Do you know where you were on August 9 between the hours of 6:30 a.m. to 8:00 a.m.?" After thinking about it for several minutes, I told Detective Williamson that I did not know

where I was on that particular day and time. I then stated that "I could've been anywhere that was almost two months ago." Detective Gonzales asked me if I would be willing to appear in a lineup. I asked Detective Gonzales, "What will happen once the lineup is completed?" Detective Gonzales told me that if I had not been picked as the person who had committed these crimes that I would be allowed to go home. I told Detective Gonzales that I would agree to appear in the lineup. Both detectives left the room, and I was escorted back to the jail cell by a uniformed officer.

Approximately two hours later, the uniformed officer came back to the jail cell and informed me that the detectives wanted to see me again. I was again escorted to a room where both detectives were present. Detective Williamson informed me that they had arranged for me to appear in two separate lineups. Detective Williamson asked me if I could afford an attorney to be present with me when I appeared at the lineup. I told Detective Williamson that I could not at this very moment afford an attorney to appear at the lineup with me. Detective Williamson informed me that he had a piece of paper, which he in turned showed to me. Detective Williamson stated that this piece of paper was a waiver of the appearance of an attorney at the lineup in my behalf. Detective Williamson told me that I could sign the waiver and they could proceed with two separate lineups. He additionally said, "If you are not identified as the person who committed these crimes, you will be allowed to walk out of here a free man." I subsequently signed the waiver form.

Approximately fifteen minutes later, I was taken before a lineup. I was wearing green pants and a black shirt. I was in a lineup with about five or six other guys. While appearing in the lineup, I was instructed by a voice of a person whom I couldn't see to take a step forward. I was then instructed to turn right; then I was instructed to turn left. I was then instructed to step back to the original spot where I was standing in the beginning.

Several minutes later, I was escorted back to the room. Subsequently after entering the room, I was instructed by the uniformed officer to take a seat. About ten to fifteen minutes later, the uniformed officer came back to the room and informed me that the

second lineup was ready for my appearance. This officer proceeded to escort me to the second lineup. Standing in the second lineup with me were about five to six more guys who were different from the guys with me in the first lineup. One by one, each guy, including myself, were instructed to step forward, turn left, and instructed to turn right, and finally instructed to step back in place. Subsequently after this lineup was over, the uniformed officer escorted me back to the room. Several minutes later both detectives also returned back to the room. Detective Williamson told me that I had been picked in the second lineup by a Mrs. Audrey Peters. Detective Williamson told me that Mrs. Peters had said that I was the guy who had robbed and raped her on August 9, 1979. Detective Williamson then told me that I had also been picked in the first lineup by a Mrs. Malveaux. He told me that Mrs. Malveaux had said that I was the guy who had attempted to rape her and that I did in fact rob her on September 27, 1979. Detective Williamson asked me if I had a statement to make. I told the detective that the only thing that I have to say is that "I didn't commit either crime." Both detectives left the room, and the uniformed officer returned and subsequently escorted me back to the jail cell.

Several days later, I was transported from the Houston Police Department City Jail to the Harris County Jail. I remained in the Harris County Jail for several weeks, and then I was transported to the rehab center (which is another holding facility for those awaiting trial and those who have already been convicted and are awaiting to be transported to the state prison).

CHAPTER 10

Criminal Proceedings

Around the end of October, I was transported to the Harris County Courthouse where I was placed in a holding cell. Several hours later, I was taken before the Honorable J. D. Guyon, judge of the 232nd Judicial District Court. When I was escorted to appear before Judge Guyon, the judge asked me if I was familiar with the charges that were filed against me. I informed Judge Guyon that I was. The judge informed me that he would read those charges to me again. Judge Guyon proceeded to read the charges of aggravated rape and aggravated robbery committed against a Mrs. Audrey Peters on August 9, 1979, and the charges of attempted rape and aggravated robbery committed against a Mrs. Malveaux. Judge Guyon asked me if I could afford an attorney. I informed him that I could not. Judge Guyon informed me that an attorney would be appointed to me. The judge then asked me how I pleaded in regard to those charges that were made against me. I informed him that I would plead not guilty to all the charges. Subsequently after my conversation with Judge Guyon, I was escorted back to the holding cell. Several hours later I was transported back to the rehab center.

Several days later, a security officer summoned me to the front of the cell block, where I was living. This officer informed me that he had some papers to serve to me. He also told me that I had to sign my signature on a piece of paper acknowledging receipt of the papers that he was about to serve me with. I then asked him what were the papers, and he told me that the papers were felony indictments, which would inform me of the charges that were currently being

made against me. I accepted the three felony indictments, and I subsequently signed my name acknowledging receipt of the indictments.

After I received the three indictments, I walked back to my cell and sat on my bunk. I proceeded to read the indictments, which read, in case number 303437 that on or about September 27, 1979, I had made an attempt to rape Mrs. Malveaux; case number 303438 read that on August 9, 1979 I had committed the act of aggravated rape against Mrs. Peters by engaging in forcible rape while placing Mrs. Peters in imminent fear of bodily harm and/or bodily injury as a result of threats; and case number 303439 read that I had committed the offense of aggravated robbery against Mrs. Malveaux on or about September 27, 1979.

For the first time since I had been incarcerated, it had finally dawned on me that I was truly being charged with these very serious crimes. I mean, from the beginning, I had realized that people were saying that I had committed a crime against them. However, up until this period in time (when I received these indictments), I had always felt that the truth would come to light and I would eventually be released. The rest of the entire night I cried until I couldn't cry anymore.

As I reflect back to my years, months, and days of incarceration, I can recall my initial placement in the city and county jails. In the city jail there were two other guys in the same cell with me, and the place (cell) reeked with the smell of urine and alcohol. We received two meals a day, which was horrible. For breakfast, there was a boiled egg, one biscuit, and a cup of coffee. The breakfast meal was always the same. For lunch and dinner (that meal was combined into one), TV dinners. The TV dinner never changed, but we did receive different type of TV dinners. I was hoping that once I left the city jail for the county jail that the living conditions would be for the better. However, this was not the case. Once I reached the county jail, myself and others were told to strip butt naked. A trusty (trusties were sometimes inmates who had been sentenced to a light prison sentence and were awaiting to be transported to prison and/or they were inmates who had received very light prison sentences and were going to serve their sentences in the county jail) proceeded to hand

us a jumpsuit-type of garment to wear. We were not issued underwear, nor socks to wear. We were also given a pair of slippers to wear. Myself along with about six more guys were escorted to a particular tank (a tank is a living quarters where people who were charged with a crime and/or who had already been convicted of a crime temporarily resided). Once we were placed inside the tank by the county officer who was working this particular floor, I noticed that there were guys sleeping on the tables (which were meant for eating and writing) and on the floor. The place was so crowded, there was barely walking room from one place to another place. I found myself a particular spot on the floor, because all of the bunks and tables were already occupied. I subsequently sat on the floor and began looking over my current surroundings. It was not like this situation had been totally foreign to me, because I had been previously incarcerated twice before.

The food in the county jail was lousy. There were meals that resembled dog and cat food. Honestly, myself nor others did not know what certain meals were, so we just named those meals cat and dog food. However, we did receive three meals a day, which was a great improvement over the city jail. Can you imagine eating only TV dinners seven days a week? And there was a rule that if you were late getting to the door to receive your meals, you would not be allowed to receive that meal. (In the county jail, a county officer would come to the front door of the tank and shout "chow time." And those of us who were assigned to the tank when chow time was called would be required to hurry up and form a line beginning at the front door of the tank.) The trusties would serve the meals.

There were also situations where guys would sell their meals for cigarettes, writing paper, envelopes, and something sweet to eat, such as cookies and candy that were sold in the commissary. And there were many times when stronger guys would take the weaker guys' meals. I was fortunate where I was never approached, nor was I ever threatened about my meal.

When I was transported to the rehab center, I really enjoyed the place, and I definitely enjoyed my stay there. This place was comfortable under the circumstances, and it also prepared people for state

prison. The structure of the rehab center was built like a miniature prison. The food at the rehab center was very good. There were also many ways to make money. I even got myself a job (cleaning window screens) to help take my mind off impending problems that loomed ahead.

The very next day after I had received those three indictments, there were several fellows questioning me about the charges that I had been charged with. Most of the fellows were asking questions, such as "Man, what did you do to get all those indictments?" And others would say, "The cops must have a lot of evidence against you to be issuing you all those indictments." There were other questions as well. In response, I would say, "Man, these people got the wrong person. They are only trying to frame these cases on me, but it won't work." I threw those indictments away that very next morning.

Several days after I was issued the three indictments, I was transported back to the Harris County Courthouse (which was sometime in November 1979) where I was subsequently placed in a holding cell. Several hours later, I was taken before Judge Guyon. Judge Guyon informed me that he had appointed Attorney Ronald Hayes to represent me against the charges alleged in the three indictments. Attorney Hayes walked up beside me and introduced himself. I acknowledged his presence, and I continued staring at the judge. Mr. Hayes instructed me to walk over to a seat and sit down. Mr. Hayes asked me if I was familiar with the charges against me. I informed him that I was. Additionally, I told Mr. Hayes that I had been previously taken before Judge Guyon several days earlier and at that time I had pleaded not guilty to all of the charges. Mr. Hayes asked me if that was going to be my continued plea today. I stated yes. Mr. Hayes asked Judge Guyon for permission to approach the bench. Judge Guyon gave him that permission. Mr. Hayes stated, "Your Honor, my client wishes to plead not guilty to all three charges and we at this time make a request for a jury trial."

Judge Guyon stated, "The record will reflect your plea and request for a jury trial."

I was subsequently escorted to a room where Mr. Hayes accompanied me. Myself and Mr. Hayes entered a room, and the bailiff

locked us in. Mr. Hayes told me to tell him what I knew about these cases.

I told Mr. Hayes that I did not know anything about these cases. I explained to him that I was almost ran over by this black guy on September 27 at around six thirty in the morning, and later that morning around eight, this same black guy jumped out of a police car, along with a policeman. Once out of his car, the policeman hollered for me to stop; I told Mr. Hayes. But I did not stop. I proceeded to run away. I told Mr. Hayes that another officer finally caught me and brought me back to where the other policeman and the black guy was waiting.

Additionally, I told Mr. Hayes, "At this time, the black guy told the police officer that I had been the one who had assaulted his wife." I continued to tell Mr. Hayes that I had told the policeman that this was the same guy that had attempted to run over me with his car earlier that morning. I continued to tell Mr. Hayes that I had told the policeman that I did not know the man, nor did I know his wife. I then informed Mr. Hayes that the arresting officers proceeded to go to a liquor store and a convenience store, where two men came outside to the police car and looked at me and the policeman asked them if I was the one and both men replied no.

Mr. Hayes asked me why I ran from the police officers. I informed Mr. Hayes that I was frightened of that black guy who had attempted to run over me with his car earlier that morning, and I also told Mr. Hayes that I had a bag of weed on my possession and I did not want to get caught with it, because I was on probation.

Mr. Hayes then asked me, "What else happened?" I explained to Mr. Hayes that I was taken to the city jail, where I spoke to two detectives. I told him that the first detective that I had spoken with began questioning me about an attempted rape and robbery that was committed against a Mrs. Malveaux. I told him that the detective told me that Mrs. Malveaux had stated that on September 27, I had robbed her of her purse and I had attempted to pull her into some bushes and rape her. Mr. Hayes asked me, "Do you know Mrs. Malveaux?" And I told him that I did not know of anyone by the name of Malveaux. I then told Mr. Hayes that a second detective

entered the room and he then began to also question me about the Mrs. Malveaux case. I informed Mr. Hayes that while the second detective was questioning me, he abruptly stated that I fit the description of this person who had committed a rape in the same area where I had been arrested and that this rape had been committed about six weeks prior to my arrest. Mr. Hayes asked me, "What did he say specifically?" I informed Mr. Hayes that the second detective had initially asked me about my gold tooth. He also stated with my high cheekbones and light skin complexion that I fit the description of a rape suspect. I further informed Mr. Hayes that the detective told me that if I would agree to go through a lineup and should I not get picked that I would be allowed to go home. I informed Mr. Hayes that I was subsequently taken through two separate lineups, where I was thereafter picked by Mrs. Malveaux and Mrs. Peters.

Mr. Hayes informed me that he had an appointment to make. However, he stated that he would see me again in about a week or two. In about two to three weeks I was transported back to the county courthouse where I once again met with Mr. Hayes. Mr. Hayes told me that he had read the police reports about the description that the victims had given. He informed me that Mrs. Peters said that her attacker had a gold tooth in his mouth, had high cheekbones, had light skin complexion, and wore a hat on the day she was assaulted. He told me that Mrs. Malveaux did not mention anything about her attacker having a gold tooth, but she did mention that her attacker bore a scar on his face.

I then told Mr. Hayes that on July 30 or July 31 of that same year, while standing at the bus stop, I had been assaulted by two men, which required me to wear bandages, and I suffered scars and bruises on my face during the time that Mrs. Peters was supposedly raped and robbed. I told Mr. Hayes that Ms. Knoxson was with me when I was assaulted, and she could also attest to the fact that I had to wear bandages and I had visible scars and bruises subsequently after the bandages were removed. Mr. Hayes stated that Mrs. Peters did not mention anything about her attacker having any scars or bruises, so this testimony could be used to impeach the testimony and identification of Mrs. Peters. Mr. Hayes then asked me if I was sure about

the scars and bruises on my face around August 9, 1979. I informed Mr. Hayes that I was positive. I informed him that I had to wear bandages for a little over a week, and then the scars and/or bruises were clearly visible on my face for about three weeks after the incident.

Mr. Hayes asked me whether Ms. Knoxson would be willing to testify at my trial. I informed Mr. Hayes that I am certain that she would testify. Mr. Hayes asked me for Ms. Knoxson's telephone number and address. I gave Mr. Hayes Ms. Knoxson's telephone number, but I told him that I would have to give him Ms. Knoxson's address during our next meeting, because I couldn't remember her address at this time. Mr. Hayes told me that Mrs. Peters stated that her attacker had a gun. He asked me if I owned a gun and I told him, "No, I did not." Mr. Hayes also told me that Mrs. Peters stated that she was robbed of a watch and some money. Additionally, he stated that Mrs. Malveaux stated that she had been robbed of her purse. I told Mr. Hayes that I did not have no reason to rob anyone because I had a job (at the time of my arrest, I was working for Carnation Milk Company, where I had been working for almost a year) working at Carnation Milk Company, where I had made almost $300 a week in salary. Additionally, I told Mr. Hayes that I currently had a little over $200 in the credit union at my job, as a result of my making deposits of $50 a week into my credit union account. Mr. Hayes stated that he had to leave, but we would meet again soon.

During the early part of December, I again met with Mr. Hayes, and at this time I informed Mr. Hayes that I had Ms. Knoxson's address. I proceeded to hand him the address on a piece of paper. I informed Mr. Hayes that I had previously spoke to Ms. Knoxson via the telephone, and she informed me that she would in fact be willing to testify in my trial. Mr. Hayes said okay; he would subpoena Ms. Knoxson to testify at my trial. Mr. Hayes informed me that he would present my defense by attacking the identification of Mrs. Peters and present my alibi the identification of Mrs. Peters and present my alibi defense in the Mrs. Malveaux case. Mr. Hayes also informed me that the assistant district attorney had offered me a plea bargain agreement of forty years for all the charges combined. I informed Mr. Hayes that I would not take any plea bargain agreement, because I

was innocent. Mr. Hayes informed me that the judge would probably be scheduling a trial date sometime very soon, so I should prepare myself to be ready for trial. Mr. Hayes asked me if there was anything else that I could think of that would be helpful in my case. I told him no. Mr. Hayes stated that he would talk to me at a later date.

On a particular day before my trial date, I was talking to Ms. Knoxson on the telephone and she informed me that a lady who identified herself as Mr. Hayes's secretary had called her and talked to her. Ms. Knoxson said that she told Mr. Hayes's secretary that she would be willing to testify at my trial. The secretary told her that she would be contacted when the time for her to testify at my trial arrived. I told Ms. Knoxson that I did not know the date when my trial would begin. However, I told her that it would be soon.

CHAPTER 11

The Illegal Trial

On December 17, 1979, I was transported back to the county courthouse. I was subsequently placed in a holding cell. Several hours later, I was escorted to this big room, maybe it was an office. Mr. Hayes and the assistant district attorney (name unknown) entered the room. Mr. Hayes informed me that the assistant district attorney was making a final plea bargain of forty years. I told Mr. Hayes that I would refuse that offer. Mr. Hayes then informed me that my trial was scheduled for today.

Mr. Hayes stated, "We will be proceeding to trial in less than an hour."

I said, "I'm as ready as I'm going to ever be."

Mr. Hayes then said, "Mr. McQueen, you don't have a serious criminal history and I know the judge of this court very well. I would suggest that you waive your right to a jury trial and proceed to trial before Judge Guyon. And should you be found guilty, I could possibly get you a probation."

I said, "Sir, I am already on probation, plus I am innocent as well."

Mr. Hayes said, "You wouldn't be pleading guilty or anything like that, you would be just placing yourself in the best situation under the circumstances."

I then turned and looked at the assistant district attorney, who was present during my entire conversation with Mr. Hayes, and I stated, "Okay, I will go to trial before the judge."

Mr. Hayes informed me that I would have to sign a waiver of my right to a jury trial. The assistant district attorney pulled out a piece of paper out of his briefcase. Mr. Hayes informed me that I would have to sign this waiver, and he additionally informed me that when we appeared before the judge, he will ask me a few questions to determine whether I knew what I was doing by signing away my right to a jury trial. I stated that I understood, and I proceeded to sign the waiver, thereby effectively signing away my right to a trial by jury.

Several minutes later, I was escorted, along with Mr. Hayes at my side, into the courtroom. Myself and Mr. Hayes were seated at a table at the left side of the courtroom facing Judge Guyon's bench. The assistant district attorney was seated at a table on the right side of the courtroom, also facing Judge Guyon's bench. Judge Guyon stated to Mr. Hayes, "I understand that your client wishes to waive his right to a jury trial."

Mr. Hayes stated, "That's correct, Your Honor."

Judge Guyon asked me if I understood that I had the right to a jury trial.

I stated, "Yes, sir."

Judge Guyon then asked me, "Were you offered anything in return for waiving your right to a jury trial?"

I stated, "No, sir."

Judge Guyon asked me, Has anyone forced you to sign your right to a jury trial?"

I again stated, "No, sir."

Judge Guyon held up the signed waiver form that I had signed, and he asked me if I had knowingly and willingly signed this waiver of my right to a jury trial.

I responded, "Yes, sir."

Judge Guyon then stated, "Okay, if both parties are ready to proceed, then we shall proceed with this trial."

Subsequently after my conversation with Judge Guyon, I began looking around the courtroom to see whether Ms. Knoxson was present. However, I did not see her. I then asked Mr. Hayes if he had subpoenaed Ms. Knoxson. Mr. Hayes stated, "I did in fact have a

subpoena served on Ms. Knoxson." I informed Mr. Hayes that Ms. Knoxson was not present in the courtroom. Mr. Hayes stated, "Don't worry, she won't be testifying today."

The state called its first witness.

Prosecutor (the prosecutor is Assistant District Attorney Chris Lorenzo): The state calls Officer William Abertson. (See fig. 1.)

Officer William Abertson was sworn in to testify.

Prosecutor: Officer Abertson, could you tell the court your occupation?

Officer Abertson: I work patrol for the Houston Police Department.

Prosecutor: And how long have you been employed with the Houston Police Department, sir?

Officer Abertson: I've been working for Houston Police Department (HPD) for about six years now.

Prosecutor: On the morning of September 27 at approximately 7:45 a.m., do you recall responding to a call from one of your fellow officers, while you were out on patrol?

Officer Abertson: Sir, while myself and my partner were making our usual rounds around the area that we were assigned to for that particular day, we received a radio call that a suspect was on foot running from another patrol car and possibly headed in our direction.

Prosecutor: And what did you and your partner do after receiving this call?

Officer Abertson: We relayed our call back to the patrol car where the call had come from, and we requested a detailed description of the suspect.

Prosecutor: Did you receive a description of the suspect?

Officer Abertson: Yes, sir.

Prosecutor: What type of description did you receive?

Officer Abertson: Black male, light skin complexion, medium built, wearing a hat, green pants, black T-shirt, and white tennis shoes.

Prosecutor: What did you and your partner do next?

Officer Abertson: We began driving the patrol car around the area looking for someone fitting this description.

Prosecutor: Did you find anyone fitting this description?

Officer Abertson: Well, not right away. We searched the area for about fifteen minutes, and then we saw someone who did fit the description.

Prosecutor: So after you saw this person who had fitted the description that was radioed in to you, what did you do next?

Officer Abertson: Well, I hollered at him to stop, police.

Prosecutor: And did he stop after you hollered at him?

Officer Abertson: No, sir, he did not. He took off running in the opposite direction.

Prosecutor: What did you do after he took off running, Officer Abertson?

Officer Abertson: I told my partner to stop the car, and I exited the car and began chasing the suspect.

Prosecutor: How far did you chase the suspect, and did you ever catch him?

Officer Abertson: I gave chase for about one block and a half, when I eventually caught up to the suspect, who was at this time out of breath and hiding behind a building.

Prosecutor: What did you do once you caught up with the suspect?

Officer Abertson: I threw my gun, and I ordered the suspect to come out from behind the building with his hands in the air. The suspect came walking from behind the building with his hands up in the air. I handcuffed the suspect and with my partner escorted him to the police car, where the suspect was placed inside the patrol car.

Prosecutor: Officer Abertson, what were you doing during the time that your partner was placing the suspect in the patrol car?

Officer Abertson: I was searching the area where the suspect had previously been hiding to see if he had hid something.

Prosecutor: What exactly, if anything, were you looking for?

Officer Abertson: I was looking for a weapon, because when we received our radio call we were warned that the suspect might be armed.

Prosecutor: And did you find anything?

Officer Abertson: No, sir.

Prosecutor: And what did you do next, Officer Abertson?

Officer Abertson: My partner and I got back inside the patrol car, and we drove back to the location where the initial officer and complaining witness were waiting. Yes, sir, once we arrived at the location, the officer and witness were waiting on us.

Prosecutor: What happened next, sir?

Officer Abertson: The officer and the complaining witness approached the patrol car and took a look at the suspect, and both said that he was the person who had previously assaulted the complaining witness's wife two days prior.

Prosecutor: What was the name of the complaining witness, and what was his wife's name?

Officer Abertson: The complaining witness's name was Mr. David Malveaux, and his wife's name was Mrs. Denise Malveaux.

Prosecutor: And did Mr. Malveaux tell you the manner that his wife had been assaulted by the suspect?

Officer Abertson: Yes, sir, he did. Mr. Malveaux said that the suspect had robbed his wife of her purse and the suspect had attempted to rape her.

Prosecutor: Officer Abertson, was Mr. Malveaux with his wife on the day that she had been assaulted by the suspect?

Officer Abertson: No, sir, he was not.

Prosecutor: How did he know who the person was that had assaulted his wife?

Officer Abertson: Mr. Malveaux told us that at approximately 6:00 a.m. on September 29 his wife came back home acting hysterical. Mr. Malveaux said that his wife told him that while she was on her way to work, she had seen the man that had assaulted her on September 27. He said that he drove out his car searching for the man. He said that he did in fact see the man that his wife had previously gave him a description of, and he made an attempt to catch him, but he was unsuccessful. He said that he then called the police. And about an hour later, the officer whom he was with came to his home, and he informed him about his wife previously being assaulted and the fact that he had seen the man, but was unsuccessful in trying to apprehend him. Mr. Malveaux said that he accompanied

the policeman, where they began searching the area and where they had come upon the suspect. He said himself and the officer gave chase of the suspect, but the suspect had gotten away.

Prosecutor: Officer Abertson, do you see the suspect whom you apprehended on September 29 in this courtroom today?

Officer Abertson: Yes, sir, I do.

Prosecutor: And where is that suspect?

Officer Abertson: He is sitting right over there. (Officer Abertson pointed at me.)

Prosecutor: I have no further questions for this witness, Your Honor.

Mr. Hayes (on cross-examination): Officer Abertson, did you or your partner witness the defendant committing any crime?

Officer Abertson: No, sir.

Mr. Hayes: And if I am right, you said that you did not find any type of weapon or anything else for that matter in the area where you apprehended the defendant? Is that also correct?

Officer Abertson: Yes, sir, that is correct.

Mr. Hayes: Did you or your partner find anything illegal on the defendant's person when you arrested him?

Officer Abertson: No, sir, we did not.

Mr. Hayes: Did you or your partner have a warrant to arrest the defendant?

Officer Abertson: No, sir, we did not. We arrested the defendant in response that another officer, along with a complaining witness, were in pursue of the defendant.

Mr. Hayes: Didn't you say that Mrs. Malveaux was the person who filed the complaint against the defendant for robbery and attempted rape?

Officer Abertson: Yes, sir, that is correct.

Mr. Hayes: Did you ever speak with Mrs. Malveaux?

Officer Abertson: No, sir, I did not.

Mr. Hayes: Did your partner ever speak with Mrs. Malveaux?

Officer Abertson: No, sir, he did not.

Mr. Hayes: So your arrest of the defendant was based totally on what was told to you by Mr. Malveaux?

Officer Abertson: Yes, sir. What Mr. Malveaux had told us and the other officer.

Mr. Hayes: I have no further questions, Your Honor.

The state next called Detective Raymond Williamson.

Prosecutor: Detective Williamson, can you tell the court how you became familiar with this case?

Detective Williamson: Well, on September 29, myself and Detective Gonzales were informed that there was a suspect in custody that had committed the crimes of robbery and attempted rape against a Mrs. Malveaux on September 27. The suspect was brought to our officer for interrogation.

Prosecutor: And do you see that suspect in this courtroom today, Detective Williamson?

Detective Williamson: Yes, sir, I do. (Detective Williamson pointed at me.)

Prosecutor: What took place during this interrogation?

Detective Williamson: I asked the defendant what did he know about a robbery and attempted rape being committed against a Mrs. Malveaux on September 27 at approximately 8:00 a.m."

Prosecutor: What did the defendant say to you?

Detective Williamson: Well, he denied having any knowledge of these crimes, and he also said that he did not know Mrs. Malveaux.

Prosecutor: Detective Williamson, did you initiate the interrogation of the defendant?

Detective Williamson: No, sir, I did not. As a matter of fact, Detective Gonzales began the interrogation of the defendant. I came a little while after the interrogation had already begun.

Prosecutor: What exactly did the defendant tell you, Detective Williamson?

Detective Williamson: Only what I've previously mentioned that he did have any knowledge of the crime, nor did he know Mrs. Malveaux. He had informed Detective Gonzales of the same and not much more prior to my entering the room.

Prosecutor: Detective, did anything occur to you during your interrogation of the defendant?

Detective Williamson: Yes, sir, something did occur. I noticed that the defendant had fit the description of another robbery and rape suspect that I had been investigating.

Prosecutor: Would you mind elaborating as to what you mean by the defendant fitting the description of a robbery and rape suspect?

Detective Williamson: Well, the defendant had a front gold tooth, high cheekbones, he had a light skin complexion, his height was close to six feet, and he weighed about the same as the suspect.

Prosecutor: When did this robbery and rape occur?

Detective Williamson: It occurred on August 9, 1979.

Prosecutor: Where did it occur?

Detective Williamson: The rape and robbery occurred right behind the Sheltering Arms Building, which was only several blocks from where the defendant was arrested.

Prosecutor: So you determined that the defendant was a suspect to this crime of robbery and rape based on the location that the defendant was apprehended in and based on the fact that his description was similar to that of the suspect?

Detective Williamson: Yes, sir, that is correct.

Prosecutor: Did you or Detective Gonzales question the defendant about this rape and robbery?

Detective Williamson: Yes, sir, I initiated the questioning subsequently after I asked the defendant about his front gold tooth.

Prosecutor: You asked the defendant about his front gold tooth?

Detective Williamson: Yes, sir, that is correct. During our interrogation of the defendant about the Malveaux case, I noticed that when the defendant responded he had a front gold tooth. So I asked him how long did he have his gold tooth. And he told me that he had had the gold tooth for several years. I then left the room and obtained the Mrs. Peters file. After rereading this file, I noticed that the defendant fit the description of the suspect in this case.

Prosecutor: You said the Mrs. Peters file. Was this the person who had filed the complaint that she had been robbed and raped on August 9?

Detective Williamson: Yes, sir. Mrs. Audrey Peters was the lady who had previously filed a complaint that she had been forceably

forced into a wooded area right behind Sheltering Arms, where she was forced to cover her face, while the suspect lifted up her dress and pulled her panties down. The suspect then had sexual intercourse with the victim. Subsequently after sexually assaulting the victim, the defendant robbed the victim of her watch.

Prosecutor: What did the defendant have to say about the crimes committed against Mrs. Peters?

Detective Williamson: The defendant said that he didn't know anything about any robbery or rape, and he said that he did not know Mrs. Audrey Peters.

Prosecutor: Did you ask the defendant any other questions about the Mrs. Peters case?

Detective Williamson: Yes, sir, I asked the defendant did he know his whereabouts on August 9, 1979, around the hours of 7:00 to 8:00 a.m. I also asked the defendant did he know where the Sheltering Arms was located and if so, had he ever been to the Sheltering Arms.

Prosecutor: What was the defendant's responses to these questions?

Detective Williamson: Well, the defendant said that he could not remember his exact whereabouts on August 9. He said that he possibly could have been at home, but he wasn't sure. He said that he was aware of the location of the Sheltering Arms. However, he said that he had never been to the Sheltering Arms, but he had passed the Sheltering Arms on numerous occasions while on his way to the bus stop to go to work and on his way home.

Chapter 12

The Lineup

Prosecutor: After you determined that the defendant fit the description of the suspect in the Mrs. Peters rape and robbery case, what did you do next?

Detective Williamson: Well, I conferred with Detective Gonzales, and we asked the defendant if he would be willing to appear in two separate lineups.

Prosecutor: Did the defendant agree to appear in the lineups?

Detective Williamson: Yes, sir, he did.

Prosecutor: Did you coordinate the lineup procedures?

Detective Williamson: Yes, sir, I did.

Prosecutor: Would you mind telling us what it was you actually did in regard to the lineups?

Detective Williamson: First of all, I contacted Mrs. Malveaux and Mrs. Peters and I informed them that we had a suspect in custody who had fit the description of the suspect that had assaulted them. I asked them if they could be at the station at 8:00 p.m. for the purpose of viewing a lineup to determine whether or not they could pick out the person who had assaulted them. Both ladies agreed to appear at the lineup. Subsequently after speaking to Mrs. Peters and Mrs. Malveaux, I spoke to several other officials, and the arrangements were made for two lineups to be conducted with the defendant in both separate lineups.

Prosecutor: Did you have any other conversations with the defendant?

Detective Williamson: Yes, sir, I did. I spoke to the defendant about having an attorney in his behalf to be present at the lineups.

Prosecutor: Exactly what did the defendant say about having an attorney in his behalf at the lineups?

Detective Williamson: Well, I informed the defendant that he had the right to have an attorney present at the lineups. However, the defendant said that he could not afford to hire an attorney. So I asked the defendant whether or not he would be willing to waive the right to have an attorney present at the lineups. The defendant subsequently agreed to waive his right to an attorney, and he stated that he would appear in the lineups without presence of an attorney.

Prosecutor: Did the defendant give you a reason for agreeing to waive his right of the presence of an attorney at the lineups?

Detective Williamson: Yes, he did.

Prosecutor: And what reason did he give you for agreeing to waive his right to an attorney?

Detective Williamson: The defendant said that he did not commit the crimes, so he wasn't worried about anyone picking him out in either one of the lineups.

Prosecutor: No further questions, Your Honor.

Mr. Hayes (on cross-examination): Detective Williamson testified that during your conversation with the defendant pertaining to the Mrs. Malveaux's robbery and attempted rape case, you noticed that the defendant had fit the description of a rape suspect in this case. Is that correct?"

Detective Williamson: Yes, sir, that is correct.

Mr. Hayes: Prior to your conversation with the defendant, had you been aware of the facts pertaining to this rape case? And if you had, would you mind explaining how you had become familiar with these facts?

Detective Williamson: Yes, I had already become familiar with the facts of this rape case against the victim Mrs. Peters as a result of my investigation into the robbery of Mrs. Peters. I work in the robbery division at HPD. So I personally investigated the robbery aspects of this case. During my investigation of the robbery, I met personally with Mrs. Peters. We had called Mrs. Peters and asked

her to come to the station for the purpose of composing a composite drawing of the man that she said assaulted her. Mrs. Peters came out to the station, and a composite drawing was completed, and I had several discussions with her pertaining to the robbery and rape.

Mr. Hayes: And you previously stated that you noticed the defendant as a suspect once you had seen the front gold tooth in his mouth. Is that also correct?

Detective Williamson: Yes, sir, that is partially correct. I also suspected the defendant due to the high cheekbones that he had, his light skin complexion, his height, his weight, and the area where he was arrested. A combination of these things aroused my suspicion of the defendant.

Mr. Hayes: Detective Williamson, in your line of work, I can imagine that you come across a number of different types of people. Some black and some white. Is this correct to say?

Detective Williamson: Yes, I would say that this is very correct.

Mr. Hayes: Detective Williamson, isn't it true that more black men have gold teeth in their mouths, than, let's say, white men?

Determine Williamson: I would agree with that assessment, that black men are more likely to have a gold tooth than a white guy would.

Mr. Hayes: Detective, were you present during the lineups?

Detective Williamson: Yes, sir, I was present during both lineups.

Mr. Hayes: Can you tell me who else was present during the lineups?

Detective Williamson: During Mrs. Malveaux's lineup, myself, Detective Gonzales, and Mrs. Malveaux were present. And during Mrs. Peters's lineup, myself, Detective Gonzales, Detective Ramsey, who works in the rape division, and Mrs. Peters were present.

Mr. Hayes: Can you describe the other guys that were in the lineup with the defendant?

Detective Williamson: From what I can recall, most guys were about the same height and weight as the defendant. There were two white guys and Hispanic guys in these lineups as well. But no one stood out, and no one told the victims who to pick out.

Mr. Hayes: Detective, at any time prior to the arrest of the defendant, had there been any other suspects in custody for the rape of Mrs. Peters?

Detective Williamson: No, sir, there had not been any other suspects in custody to the best of my knowledge.

Mr. Hayes: No further questions, Your Honor.

CHAPTER 13

Testimony of Malveaux

The state next called Mrs. Denise Malveaux. (This is where things began to become surreal for me. Immediately upon seeing Mrs. Malveaux, I realized that I did in fact know her.)

Prosecutor: Mrs. Malveaux, would you mind explaining to the court what took place with you being assaulted on September 27, 1979?

Mrs. Malveaux: Yes, I was walking to the bus stop on my way to work when this man approached me from behind. He said, "Good morning," and he asked me if I had change for a dollar. I told him that I did not have change for a dollar. The man said, "Thank you," but he continued to walk alongside me. Suddenly the man grabbed me around my neck and attempted to pull me behind a building.

Prosecutor: What did you do when this man was attempting to pull you behind the building?

Mrs. Malveaux: I began screaming, and I also began pulling away from the man.

Prosecutor: Mrs. Malveaux, what did your attacker do then once you attempted to pull away from him?

Mrs. Malveaux: He began dragging me in the direction of the building.

Prosecutor: What did you do then?

Mrs. Malveaux: I pulled away from him with all my might, and I was able to get free of him.

Prosecutor: What happened next?

Mrs. Malveaux: The man picked up my purse off the ground, and he ran away.

Prosecutor: You say he took your purse?

Mrs. Malveaux: Yes, sir, while he and I were tugging with each other, my purse fell on the ground. Once I was able to free myself from him, he picked up my purse and ran.

Prosecutor: Mrs. Malveaux, do you see this man that assaulted you on September 27 in this courtroom today?

Mrs. Malveaux: Yes, sir, I do. (And she pointed at me.)

Prosecutor: What happened after the defendant took your purse and ran away?

Mrs. Malveaux: Well, I ran inside the building asking that someone help me, because this man had assaulted me. And two men who were inside of the building asked me what had happened. I explained to them what had happened, and I told them how that attacker looked. The two men went out looking for the man, and they eventually came back with my purse.

Prosecutor: About what time did this assault take place?

Mrs. Malveaux: About 7:30 am.

Prosecutor: So you did get your purse back?

Mrs. Malveaux: Yes, I did.

Prosecutor: Was anything taken from your purse?

Mrs. Malveaux: No, everything was still there.

Prosecutor: Did you notify the police about this assault?

Mrs. Malveaux: Yes, sir, I did call the police after I got to work. A police officer came out to talk with me, and I gave him a description of the man that had assaulted me.

Prosecutor: What description did you give the police?

Mrs. Malveaux: I told the policeman that the man was about 6 feet tall and weighed about 170 pounds. He had short hair, several bruises on his face, and he had a light skin complexion.

Prosecutor: Do you know the defendant?

Mrs. Malveaux: No, sir, I do not.

Prosecutor: Do you know if the defendant had a gun or any type of weapon?

Mrs. Malveaux: No, sir, I don't know if he had a gun or not.

Prosecutor: Did the defendant in any way make any threats towards you?

Mrs. Malveaux: He did not make any verbal threats, if that's what you're asking.

Prosecutor: Were you in fear of being hurt by the defendant when he attacked you?

Mrs. Malveaux: Yes, I was very frightened and scared of being hurt or injured by the defendant.

Prosecutor: Mrs. Malveaux, did you happen to see the defendant again after the September 27 assault against you?

Mrs. Malveaux: Yes, sir, I saw the defendant again on September 29, two days after I was assaulted, a few blocks from where he had assaulted me on September 27. And I also saw him at the police station at the lineup."

Prosecutor: When you saw the defendant on September 29, a few blocks from where he had previously assaulted you, what was the defendant doing?"

Mrs. Malveaux: He was just walking down the street at about six in the morning.

Prosecutor: How did you know that this was the same man who had assaulted you on September 27?

Mrs. Malveaux: By his appearance. He was wearing what looked like to be the same pair of green pants and black shirt. And I just remembered him by his physical appearance as being that same man.

Prosecutor: What were you doing when you saw the defendant on September 29?

Mrs. Malveaux: I was riding with a friend of mine. She was taking me to work. After the first assault, I didn't want to take any more chances walking to the bus stop.

Prosecutor: And you saw the defendant a few blocks from where the assault took place on September 27?

Mrs. Malveaux: Yes, he was walking only a few blocks from where he had previously assaulted me, and this was also only a few blocks from where I lived.

Prosecutor: What did you do once you saw the defendant?

Mrs. Malveaux: I asked my friend to drive me back to my house. Once I got back home, I immediately went inside to tell my husband that I had seen the defendant again. My husband told me to call the police, and he said that he was going to go out to see if he could find the defendant.

Prosecutor: Were you able to talk to the police?

Mrs. Malveaux: Yes, sir, I talked to a policeman, and I told the person on the phone my name, and I explained to that person about my initial complaint on September 27 and that I had just seen the man that had assaulted me.

Prosecutor: What were you instructed to by the police?

Mrs. Malveaux: The policeman told me to wait and that they were going to send someone out to talk to me.

Prosecutor: Did you talk to anyone from the police department, while you were at your home?

Mrs. Malveaux: Yes, on the telephone.

Prosecutor: I mean, where you at home to talk with the police once the police came out to your home?

Mrs. Malveaux: No, I did not. I did not stay home. I eventually went to work. My husband came back, and he said that he didn't see anyone. So I asked him to wait and talk to the police.

Prosecutor: How did you find out that the defendant was in police custody?

Mrs. Malveaux: My husband called me while I was at work, and he told me that the police had captured the defendant.

Prosecutor: Did you talk to anyone about appearing at a lineup?

Mrs. Malveaux: Yes, sir, I did talk to a detective later on that night, and he asked me if I would be willing to appear at a lineup later that night to determine if I could identify the man that had assaulted me on September 27.

Prosecutor: Did you appear at this lineup?

Mrs. Malveaux: Yes, sir, I did.

Prosecutor: Who did you meet at this lineup?

Mrs. Malveaux: I met two detectives that said that they worked in the robbery division at HPD and they would be conducting the lineup.

Prosecutor: Did the detectives tell you anything about the lineup and/or the manner that the lineup was going to be conducted?"

Mrs. Malveaux: Yes, sir, I was told that there would be five to six men standing in front of a glass window and if I saw the man that had assaulted me on September 27 to point him out to detectives.

Prosecutor: Did you see that man?

Mrs. Malveaux: Yes, sir, I pointed out the defendant.

Prosecutor: Did anyone tell you who to pick out?

Mrs. Malveaux: No, sir.

Prosecutor: No further questions for this witness, Your Honor.

Mr. Hayes (on cross-examination): (Prior to Mr. Hayes questioning of Mrs. Malveaux, I told him that I knew Mrs. Malveaux from somewhere, but I couldn't recall exactly where) Mrs. Malveaux, you previously testified that yourself and the defendant had talked prior to him assaulting you. Is that correct?

Mrs. Malveaux: Yes, that is correct.

Mr. Hayes: So can you tell me how long did you get the opportunity to see the defendant's face?

Mrs. Malveaux: About ten to fifteen seconds.

Mr. Hayes: Can you tell me if the defendant had a gold tooth?

Mrs. Malveaux: I don't recall seeing any gold tooth.

Mr. Hayes: Prior to this assault, had you known the defendant or even seen the defendant before?

Mrs. Malveaux: I know for a fact that I didn't know the defendant, and I am sure that I've never seen him prior to him assaulting me.

Mr. Hayes: Mrs. Malveaux, you testified that the defendant took your purse, but you were able to recover your purse. Can you tell me what, if anything, was taken from your purse?

Mrs. Malveaux: Actually nothing was taken from my purse. The only thing that I had in my purse was my identification and pocket change to catch the bus.

Mr. Hayes: So your identification and pocket change was still in your purse?

Mrs. Malveaux: Yes, that is correct.

Mr. Hayes: Did you notice any facial scars and/or bruises on the face of the man that attacked you?

Mrs. Malveaux: Yes, I noticed him having two facial scars above the nose and below one of his eyes.

Mr. Hayes: Were you with the police when the defendant was arrested?

Mrs. Malveaux: No, I was not, but my husband was.

Mr. Hayes: At any time when you were assaulted had your husband witnessed this assault?

Mrs. Malveaux: No, he did not.

Mr. Hayes: Can you tell me how your husband knew that the defendant was the man that had assaulted you?

Mrs. Malveaux: Because of both occasions when I saw the defendant I gave my husband a complete description of him.

Mr. Hayes: At no time did you point out the defendant as the man who had assaulted you to your husband?

Mrs. Malveaux: No, my husband was not with me on the two occasions that I saw the defendant.

Mr. Hayes: (Before Mr. Hayes could question Mrs. Malveaux again, I informed him that I wanted to speak with him. Mr. Hayes walked over to the table where I was, and he asked me what did I want. I told him that I can vaguely remember where I knew Mrs. Malveaux from. I told him that she and I attended the same high school. But I told him that I could not recall whether it was when I attended Abraham Lincoln or when I attended Jack Yates.) Mrs. Malveaux, can you tell me the names of the high schools that you attended?

Mrs. Malveaux: I attended Ryan Junior High and Abraham Lincoln High School.

Mr. Hayes: Can you tell me the years that you attended Abraham Lincoln?

Mr. Malveaux: I attended Lincoln in 1974 and 1975.

Mr. Hayes: (Mr. Hayes asked me if I attended Lincoln in 1974 and 1975. I told him that I did.) Mrs. Malveaux, do you know the defendant from attending Lincoln High School with you?

Mrs. Malveaux: No, I do not.

Mr. Hayes: Mrs. Malveaux, could it be possible that you know the defendant from Lincoln High School, instead as him being the man that assaulted you on September 27?

Mrs. Malveaux: No, I don't think so.

Mr. Hayes: No further questions, Your Honor.

The case was recessed until the next day, December 18, 1979.

Chapter 14

Testimony of the Victim

The state next called Mrs. Audrey Peters.

Prosecutor: Mrs. Peters, would you explain to the court what occurred on August 9, 1979?

Mrs. Peters: At approximately 6:30 a.m., I was exiting Sheltering Arms, which is a place where I do volunteer work. As I was walking into the parking lot towards my car, a man grabbed me from behind and he placed a gun into my back. This man told me to walk over to an area where some bushes were, and he told me not to make a sound or he would kill me. Once we reached the bushes, the man threw me on the ground and he pulled my skirt over my face. Once he had my skirt over my head, he pulled my panties down and he inserted his penis into my private parts. He then performed sexual intercourse. Once he completed the sexual intercourse, he took my watch off my wrist and he took off running.

Prosecutor: Were you able to see this man's face during the time he was raping you?

Mrs. Peters: No, I wasn't able to see his face while he was raping me, because he pulled my skirt over my head. But I was able to see his face before he pulled my skirt over my head.

Prosecutor: And how much time did you have to see his face before he pulled your skirt over your head?

Mrs. Peters: About two to three seconds.

Prosecutor: By viewing the man's face for such a brief time did not affect your ability to identify the man that raped you?

Mrs. Peters: No, it did not.

Prosecutor: You said that your attacker also had a gun. Can you tell me what this gun looked like?

Mrs. Peters: The gun was a small gun and it was black.

Prosecutor: Do you know what type of gun it was?

Mrs. Peters: No, I do not.

Prosecutor: You said that your attacker also robbed you of your watch?

Mrs. Peters: Yes, sir, I had on my watch, and he took the watch off my arm and ran away.

Prosecutor: Did you give this man consent to have sexual intercourse with you?

Mrs. Peters: No. sir, I did not.

Prosecutor: Did you give this man consent to take your watch?

Mrs. Peters: No, sir, I did not."

Prosecutor: Did this man make any threats to harm you if you did not cooperate with him?

Mrs. Malveaux: Yes, sir, he repeatedly told me to shut up and that if I screamed and resisted he would kill me.

Prosecutor: When you were being assaulted, were you afraid that you would be harmed or even killed, if you didn't cooperate with this man?

Mrs. Peters: Yes, I was in fear that he would kill me if I didn't cooperate.

Prosecutor: How long did this sexual assault occur?

Mrs. Peters: About ten to fifteen minutes. I'm not really sure. But it wasn't much longer than that.

Prosecutor: Mrs. Peters, did you make any attempts to call out for help or did you try to scream?

Mrs. Malveaux: No, sir, I did not, because I was afraid that if I had tried to scream or holler for someone to help me that I would be harmed or killed by the man.

Prosecutor: Do you know whether or not your attacker ejaculated during intercourse with you?

Mrs. Peters: No, I do not know whether he did or not.

Prosecutor: Subsequently after the suspect raped and robbed you and proceeded to run away, could you at that time see his face?"

Mrs. Peters: No, I could not. I could only see him from the backside. However, I did see the clothes that he was wearing.

Prosecutor: What was the suspect wearing?

Mrs. Peters: He was wearing a black shirt and black pants.

Prosecutor: After the suspect ran away, what did you do?

Mrs. Peters: I pulled up my panties and let down my skirt, and I ran inside the Sheltering Arms Building. Once I got inside, I started crying and I spoke to one of the ladies that was working there, and I asked her for help."

Prosecutor: Did you know the lady that you asked for help?

Mrs. Peters: Yes, her name is Mrs. Rene Foster.

Prosecutor: What did you tell Mrs. Foster?

Mrs. Peters: I told her that some man had just raped me in the parking lot, and I told her that he had a gun that he threatened to kill me with.

Prosecutor: What did Mrs. Peters do once you told her this?

Mrs. Peters: Mrs. Foster told one of the other ladies to call the police.

Prosecutor: Did the other lady call the police?

Mrs. Peters: Well, she eventually called the police, but at first I told her that I did not want to talk with the police.

Prosecutor: And why didn't you want to talk to a police officer?

Mrs. Peters: I just didn't know whether or not I wanted to get involved with the police about a matter so serious.

Prosecutor: But you did eventually agree to allow the other lady to call the police. Correct?

Mrs. Peters: That is correct.

Prosecutor: What condition were you in when you were talking to Mrs. Foster?

Mrs. Peters: I was shaking and hysterical. I could not talk normally.

Prosecutor: Why were you in this condition?

Mrs. Peters: I was a total wreck as a result of my being raped and threatened with a gun. I just couldn't think straight.

Prosecutor: Did you speak with the police after they arrived?

Mrs. Peters: Yes, I did.

Prosecutor: And what did you tell the police?

Mrs. Peters: Well, there was only one police and I told him what had occurred after I had walked to my car. I explained the details about a man walking up behind me with a gun in his hand and that the man had threatened to kill me if I screamed or made any attempt to get away from him. I also explained how I had been raped and robbed of my watch after I was raped. And I gave the officer a description of the man that had assaulted me.

Prosecutor: After the officer took this information from you, did the officer tell you something that you needed to do?

Mrs. Peters: Yes, the officer told me that I needed to go to the local hospital and take a rape kit test.

Prosecutor: Did you agree to take this rape kit test?

Mrs. Peters: Yes, I eventually agreed to take the test. But before I did agree to take the test, I asked the officer what was the test for.

Prosecutor: And what did the officer tell you that this test was for?

Mrs. Peters: He told me that the rape kit was for the purpose of determining the severity of the sexual assault, to determine whether or not I had been physically injured, and he also said that the test was for determining whether or not the discernible evidence had been left behind.

Prosecutor: Did the officer tell you what might this discernible evidence be?

Mrs. Peters: Yes, he told me that this evidence could be foreign hair and/or sperm.

Prosecutor: Did you provide the officer with additional information?

Mrs. Peters: No, sir, only the information that I've previously testified to.

Prosecutor: So what happened after your conversation with the officer had come to a conclusion?

Mrs. Peters: Well, Mrs. Foster drove me to the hospital, and we followed the officer to the hospital.

Prosecutor: What hospital did you go to?

Mrs. Peters: We went to Ben Taub Hospital.

Prosecutor: What happened once you reached the hospital?

Mrs. Peters: We followed the officer to the sixth floor, and he told us to wait while he had a talk with the doctor.

Prosecutor: Did you ever speak with a doctor while you were there?

Mrs. Peters: Yes, the policeman came back to where we were sitting and a doctor accompanied him. The officer introduced a Dr. Ralwing. Dr. Ralwing informed me that he was a gynecologist and he had often performed rape kit tests on women who had been sexually assaulted. Mr. Ralwing explained to me just how a rape kit test was conducted. He told me that the procedure was extremely safe. And he asked me if I would be willing to allow him to perform the test on me."

Prosecutor: Did you agree to allow Dr. Ralwing to perform the rape kit test?

Mrs. Peters: Yes, I did.

Prosecutor: Mrs. Peters, would you mind explaining exactly what was done to you during this examination?

Mrs. Peters: Dr. Ralwing did a physical examination of my vagina and the area surrounding my vagina. He inserted a swab stick inside my vagina, and he subsequently smeared the swab stick on a thin piece of glass. He asked me if I had experienced any pain and whether I was currently experiencing pain. Which I told him no, I had not. Dr. Ralwing then told me that he would need my panties, panty hose, and the dress that I was wearing, so these items could be taken to the police department to be tested as well. The doctor informed me that the hospital would provide me with sufficient clothing, so I could get home in. I proceeded to give the doctor my clothing (panty hose, panties, and dress), which he in turn gave to the police officer. Dr. Ralwing informed me that this would be all, and he told me that should I begin experiencing any type of physical problems to immediately contact the hospital.

Prosecutor: Did you speak to the officer about your clothing?

Mrs. Peters: Yes, the officer told me that my clothing would be taken to the police department to be tested, and he also said that my

clothing might be needed as evidence in trial should the suspect be found.

Prosecutor: Did you have any other conversations with the officer?

Mrs. Peters: Prior to leaving, he told me that someone from the police department will be in contact with me if additional information is needed or in the event the suspect is found.

Prosecutor: Were you ever contacted by the police again, Mrs. Peters?

Mrs. Peters: Yes, I was contacted by a detective, and he informed that I needed to come to the police station for the purpose of aiding an officer in completing a composite drawing of the person that assaulted me.

Prosecutor: Can you explain what it was that you did to aid in completing a composite drawing of the suspect?

Mrs. Peters: Well, this officer that I spoke to said that he was an expert who prepared composite drawings of suspects to aid the police department in identifying and apprehending criminals. He took me to this room, and he asked several questions about the facial features of the suspect. Such as the color of his eyes, his facial features, anything that might have stood out about the suspect's teeth and facial features, such as whether or not the suspect had any facial scars or permanent marks, his skin complexion, and stuff like that. Once I gave the officer description of a certain feature of the suspect's face, he would draw this description on a piece of paper. Then he would show the drawing to me and ask me if this looked like what I saw as the suspect's facial description to be. For about an hour and a half, I gave the officer information pertaining to the suspect's description, until finally I agreed that the composite drawing resembled the suspect.

Prosecutor: Once the composite drawing was completed, were you sure that the drawing resembled the man that had assaulted you on August 9?

Mrs. Peters: Yes, I was very certain that the composite drawing looked very similar to the man that had assaulted me.

Prosecutor: Is this the composite drawing that you helped in preparing and completing with the police officer? (At this moment, the prosecutor was holding up a sketch of a drawing of a person's facial features.)

Mrs. Peters: (Mrs. Peters looked at the drawing, which was being shown to her by the prosecutor) Yes, that is it.

Prosecutor: Mrs. Peters, would you mind giving a description of your attacker for the benefit of the court?

Mrs. Peters: He had a slim build, black male about 28 or 30 years old, black hair, light-skinned complexion, high cheekbones, weighed about 158 pounds, and he had a gold tooth on one of his front teeth.

Prosecutor: Mrs. Peters, would you mind looking at the defendant sitting over there at that table? Does the defendant look like the description of the man that you gave to the police who completed this composite drawing?

Mrs. Peters: Yes, sir, he does.

Prosecutor: Your Honor, the state would like to enter the composite drawing as state's exhibit number one.

The court: Do you have any objections, Mr. Hayes?

Mr. Hayes: We have no objections, Your Honor.

The court: The record will reflect the state's exhibit number one.

Prosecutor: Mrs. Peters, did you hear from the police department any time at a later date?

Mrs. Peters: Yes, sir, I did.

Prosecutor: When did you hear from the police department again?

Mrs. Malveaux: On September 29.

Prosecutor: Can you tell me why you were contacted again by the police department?

Mrs. Peters: I was informed by a detective that they had a suspect in custody and they wanted me to come down to the police station for the purpose of a lineup, so I could identify the suspect.

Prosecutor: What happened once you reached the station?

Mrs. Peters: I was escorted to this room by a detective. Once I reached this room, two more detectives were present, and they introduced themselves to me. They said that they had worked in the robbery and rape divisions. I was given a seat, and they explained to me how the lineup was going to be conducted.

Prosecutor: And how did they tell you the lineup was going to be conducted?

Mrs. Peters: One of the detectives pointed towards a glass window, and he told me that in about fifteen minutes about five or six suspects were going to line up on the other side of the glass window. He said that I will be able to see the suspects, but they won't be able to see me. The detective told me that once I recognized the man that assaulted me that I should point him out.

Prosecutor: Tell me what happened once the lineup began?

Mrs. Peters: I noticed six men walk out on the other side of the glass, and one of the detectives was speaking through a microphone, and he instructed the men to step forward, turn to the left, and then turn to the right. He instructed them to smile when they were facing the glass, and then he told them to step back in place. When this one man stepped up and smiled, I pointed him out to the detectives.

Prosecutor: So you are saying that the man that you pointed out to the detectives at the lineup was the same man that robbed and raped you on August 9?"

Mrs. Peters: Yes, sir, that is what I'm saying.

Prosecutor: Mrs. Peters, do you see that same man in this courtroom today that you picked out at the lineup?

Mrs. Peters: Yes, sir, I do.

Prosecutor: Would you mind identifying this man for the benefit of the court and for the record?

Mrs. Peters: It was that man sitting right over there, the defendant.

Prosecutor: Let the record reflect that Mrs. Peters had just identified the defendant as the man that robbed and raped her on August 9, 1979. Did you have any further discussions with the detectives?

Mrs. Peters: Yes, sir, this one detective asked me if I was positively sure that this was the man, and I told him yes, I was positively

sure that he was the man. The detective told me that I could leave now, but I could expect to be hearing from someone from the district attorney's office real soon.

Prosecutor: Mrs. Peters, I have something for you to look at. (He showed her the rape kit.) Mrs. Peters, do you recognize this object that I have in my hand?

Mrs. Peters: Yes, it looks exactly like the rape kit that the doctor at the hospital used to perform the rape kit test.

Prosecutor: Mrs. Peters, this is the same rape kit that was used to perform the test on you. Mrs. Peters, do you recognize the name that is tagged on to this rape kit?

Mrs. Peters: Yes, that's it with my name.

Prosecutor: Your Honor, the state would like to enter the rape kit as state's exhibit number two.

The court: Mr. Hayes, do you have any objections?

Mr. Hayes: No, Your Honor, we have no objections.

The court: The record will reflect the state's exhibit number 2.

Prosecutor: Mrs. Peters, do you recognize these panties that I am holding in this plastic bag?

Mrs. Peters: (She looked at the panties in the plastic bag.) Yes, those are the panties that I was wearing when I was raped, the same panties that I gave to the police officer, so they could be tested.

Prosecutor: Your Honor, the state would like to enter the panties into evidence at state's exhibit number three.

The court: Mr. Hayes, do you have any objections?

Mr. Hayes: No objections, Your Honor.

The court: The record will reflect the state's exhibit number three.

Prosecutor: Mrs. Peters, do you recognize these panty hose that I have in this plastic bag?

Mrs. Peters: Yes, these look like the panty hose that I was wearing on the day that I was raped.

Prosecutor: Your Honor, the state would like to enter the panty hose into evidence as state's exhibit number four."

The court: Any objections, Mr. Hayes?

Mr. Hayes: No objections, Your Honor.

SILENCED BUT DETERMINED

Prosecutor: Mrs. Peters, do you recognize this dress that I have in this bag?

Mrs. Peters: (She looked at the dress.) Yes, this is the same dress that I was wearing on the day that I was raped.

Prosecutor: Your Honor, the state would like to enter the victim's dress into evidence as state's exhibit number five."

The court: Any objections, Mr. Hayes?

Mr. Hayes: No objections, Your Honor.

Mr. Hayes (on cross-examination): Mrs. Peters, you previously testified that you only had a few seconds, maybe three to five to view the defendant's face before he pulled your skirt over your head. Is that correct?

Mrs. Peters: Yes, that is correct.

Mr. Hayes: And you previously testified that on September 29, you were called to the police station for a lineup. Were you eventually able to pick out the defendant as the man that raped and robbed you on August 9. Is that also correct?

Mrs. Peters: Yes, sir, that is also correct.

Mr. Hayes: Mrs. Peters, the date of the robbery and rape was August 9, and you didn't view the lineup until September 29. So how can you be positively sure that the defendant was the man who attacked you, when you only had about three to five seconds to view your attacker's face?

Mrs. Peters: I don't know, all I know is that I can remember the defendant as being the man who attacked me.

Mr. Hayes: But, Mrs. Peters, you stated that you were afraid and hysterical subsequently after the assault. Isn't it possible that your state of mind at the time of the assault could have an effect on who you thought was the person who had assaulted you?

Mrs. Peters: That's possible, however, I am quite sure that the defendant was the same man who assaulted me.

Mr. Hayes: Mrs. Peters, did your attacker bare any bruises *and/or* noticeable scars on his face that you were aware of?

Mrs. Peters: No, not that I could tell. The only thing that stuck out about the man who attacked me was the fact that he had a gold tooth.

Mr. Hayes: Mrs. Peters, can you describe the gold tooth that your attacker had?

Mrs. Peters: What do you mean "describe the gold tooth?"

Mr. Hayes: I'm asking you was the gold tooth a solid plate of gold or was it an open-face crown?

Mrs. Peters: I could not tell.

Mr. Hayes: Is it possible that your thoughts of the man who attacked you could be that of someone else? That is, someone who looks like the defendant?

Mrs. Peters: Yes, that's possible. However, I believe that the defendant is the man that assaulted me.

Mr. Hayes: You previously testified that the defendant displayed a gun and threatened you with that gun. Is that correct?"

Mrs. Peters: "Yes that is correct."

Mr. Hayes: Can you describe the gun?

Mrs. Peters: It was black and small.

Mr. Hayes: And how long were you able to see this gun?

Mrs. Peters: Briefly, maybe about two to three seconds. Maybe less.

Mr. Hayes: So, Mrs. Peters, how can you be sure that the instrument that you say the defendant had was a pistol? Couldn't it have possibly been a toy or something else?

Mrs. Peters: I am sure because the defendant told me that if I screamed or made any noise that he would kill me, and when he was telling me this, he was pointing the gun in my back.

Mr. Hayes: During your time at the police station for the purpose of viewing the lineup, did any one of the detectives tell you who you should pick out of the lineup as the man that raped and robbed you?

Mrs. Peters: No, sir, the one detective told me to view the glass window and if I saw the man that had assaulted me to pick that man out. Which I did. And that was the defendant.

Mr. Hayes: You testified that you didn't initially want to contact the police. Can you tell me why?

SILENCED BUT DETERMINED

Mrs. Peters: Because I was afraid and I didn't want my husband to find out about this, nor did I want any kind of trouble, because I am from the Virgin Islands.

Mr. Hayes: Mrs. Peters, you had been physically assaulted with a gun, so how could you possibly think that reporting this incident to the police would somehow get you into trouble?

Mrs. Peters: I don't know. I guess that I was scared, and I didn't know what my husband would think and how this would be looked upon, because I am not from the States."

Mr. Hayes: I have no more questions for this witness.

CHAPTER 15

Testimony of Diana Foster

Prosecutor: I would like to at this time call Mrs. Diana Foster to the witness stand. Mrs. Foster, do you know the victim in this case, Mrs. Peters?

Mrs. Foster: Yes, sir, I do.

Prosecutor: Can you tell us about your relationship with Mrs. Peters?

Mrs. Foster: Yes, sir, myself and Mrs. Peters have a working relationship at the Sheltering Arms. Together we aid elderly people, and we also do volunteer work at Sheltering Arms."

Prosecutor: On the early morning hours of August 9 of this year, were you and Mrs. Peters at the Sheltering Arms?

Mrs. Foster: Yes, sir, myself, Mrs. Peters, and several other ladies were at the Sheltering Arms having a meeting.

Prosecutor: How long did this meeting last, Mrs. Foster?

Mrs. Foster: This meeting lasted about an hour.

Prosecutor: At the conclusion of this meeting, what did you ladies do?

Mrs. Foster: Myself and several other ladies were hanging around inside the building talking. But Mrs. Peters left, because she said that she had some business to take care of.

Prosecutor: Did you happen to see Mrs. Peters again after she left?

Mrs. Foster: Yes, sir, several minutes after Mrs. Peters walked out the door, she came back into the building.

Prosecutor: Did Mrs. Peters say anything to you or anyone else once she reentered the building?

Mrs. Foster: Well, sir, she was crying and she was very upset. And once we went up to her to see what was wrong, she said that she had just been raped.

Prosecutor: Are you saying that once she came back inside the building she was crying, very upset, and she said that she had been raped?

Mrs. Foster: Yes, sir.

Prosecutor: Did she say anything else?

Mrs. Foster: Well, she was just crying and she kept saying, "He raped me. He had a gun and I didn't know what to do."

Prosecutor: What transpired next?

Mrs. Foster: One of the other ladies asked Mrs. Peters where did this assault take place, and Mrs. Peters said that it happened in the parking lot. Mrs. Chambers said that she was going to call the police.

Prosecutor: While you ladies were waiting for the police to arrive, what was Mrs. Peters doing?

Mrs. Foster: She was continually crying and shaking. She was very nervous and she kept saying, "Why did this happen to me?

Prosecutor: Were you able to calm down Mrs. Peters?

Mrs. Foster: Yes, sir, after about ten minutes she calmed down a little. But she was still in bad shape.

Prosecutor: What happened once the police arrived?

Mrs. Foster: Well, one of the ladies escorted the officer to where we were, and myself and Mrs. Chambers told him that Mrs. Peters had just been raped.

Prosecutor: What happened next?

Mrs. Foster: Mrs. Peters began telling the officer about how she had been approached by this man, who had a gun, and he forced her into the nearby bushes alongside the building, and the man forcibly raped her. She also gave the police a description of the man.

Prosecutor: What did the officer do once he received the information from Mrs. Peters?

Mrs. Foster: The police officer stated that he was going to notify other police units, so that a search for this man could begin immedi-

ately. The officer left and walked out to his car. He did return several minutes later.

Prosecutor: When the police officer returned, what did he say to Mrs. Peters?

Mrs. Foster: He told her that she would have to go to the hospital and take some type of test. Yes, sir, I believe that is what he said.

Prosecutor: What did Mrs. Peters say to this?

Mrs. Foster: At first, she said that she didn't want to go through nothing like that.

Prosecutor: Did she say why?

Mrs. Foster: The only thing that I can recall her saying was that her husband wouldn't be able to understand.

Prosecutor: What did the officer say to this?

Mrs. Foster: Well, the officer assured her that this procedure was totally safe and not painful. He also told her that she needed to submit to this procedure, because it would be needed as evidence that she had been raped.

Prosecutor: What did Mrs. Peters say to this?

Mrs. Foster: She said that she would agree to going to the hospital, so this procedure could be conducted. I also agreed to go with her.

Prosecutor: Can you tell me what occurred once you reached the hospital?

Mrs. Foster: We met with this doctor. This doctor and the officer escorted Mrs. Peters into a room. After they remained in the room for about thirty to forty minutes. After they came out of the room, Mrs. Peters was allowed to go home.

Prosecutor: I have no further questions.

Mr. Hayes (on cross-examination): Mrs. Foster, at any time did you happen to witness this assault committed against Mrs. Peters?

Mrs. Foster: No, sir.

Mr. Hayes: Are you saying that you never saw the person that assaulted Mrs. Peters?

Mrs. Foster: "No, sir, I never saw this person. It's like I said earlier I was inside the building when Mrs. Peters came back in and said that she had been raped.

Mr. Hayes: Mrs. Foster, do you know why Mrs. Peters would be reluctant to go to the hospital for the rape test?"

Mrs. Foster: No, sir, I have no idea. All I know is that she said that she didn't want her husband to be upset.

Mr. Hayes: What do you think that she meant by that?

Mrs. Foster: I don't know, sir.

Mr. Hayes: I have no more questions, Your Honor.

Chapter 16

Testimony of Dr. Ralwing

Prosecutor: The state next calls Dr. Robert Ralwing. Dr. Ralwing, can you tell me what your position is and where do you work?

Dr. Ralwing: I am a gynecologist and I am employed at Ben Taub Hospital.

Prosecutor: Where is Ben Taub Hospital located?

Dr. Ralwing: It is located on the southwest side of Houston near the Houston Zoo.

Prosecutor: Dr. Ralwing, do you recall seeing the victim in this case, Mrs. Peters, on August 9, 1979?

Dr. Ralwing: Yes, sir, I recall examining Mrs. Peters on August 9, 1979.

Prosecutor: Dr. Ralwing, would you mind explaining the purpose of your examining Mrs. Peters?

Dr. Ralwing: Well, Mrs. Peters was brought to the hospital by Officer Newcomb. Officer Newcomb informed me that Mrs. Peters had been forceably raped and a rape kit needed to be prepared for evidence.

Prosecutor: Dr. Ralwing, had you performed this type of procedure before?

Dr. Ralwing: Yes, sir, I have examined numerous women who were sexually assaulted. Usually, when a forceable rape occurs on the southwest side of town, the women are brought to Ben Taub for examination and treatment.

Prosecutor: Can you explain the procedure that you performed on Mrs. Peters?

Dr. Ralwing: Okay, I examined the vaginal area to determine whether there were any tears, irritation, and/or blood in the vagina. I additionally examine to determine whether sexual intercourse had actually occurred, and I make an attempt to determine how long ago this sexual intercourse had occurred.

Prosecutor: What were your findings subsequently after examining Mrs. Peters?

Dr. Ralwing: I found deposits of sperm. However, I could not determine how long ago sexual intercourse had occurred. Mrs. Peters's hymen did not reflect the look as though sexual intercourse had occurred within a forty-eight-hour time period.

Prosecutor: So, Dr. Ralwing, are you saying that your examination of Mrs. Peters did not reflect that she had sexual intercourse within a forty-eight-hour period?

Dr. Ralwing: Yes, sir, that's exactly what I'm saying. The hymen did not reflect sexual intercourse within a forty-eight-hour period of time. And from the small deposit of sperm, I could not determine whether this was deposited within a forty-eight-hour period of time.

Prosecutor: Was there anything that you noticed which would reflect recent sexual intercourse?

Dr. Ralwing: "No, sir, I noticed that there wasn't any damage done to the vaginal area, nothing consistent with a forceable rape.

Prosecutor: Are you saying that Mrs. Peters could not have been forceably raped?

Dr. Ralwing: No, sir, I am not saying that either. But what I am saying from my findings, there was no physical evidence which would reflect that a forceable rape being committed on Mrs. Peters at least within a forty-eight-hour period of my examination.

Prosecutor: Dr. Ralwing, do you know if there were any clothing items taken from Mrs. Peters for the purpose of examining as well?

Dr. Ralwing: Yes, Officer Newcomb took several clothing items from Mrs. Peters, so that these items could be taken to the Houston Police Department, so tests could be taken.

Prosecutor: Can you tell me what these clothing items were?

Dr. Ralwing: Yes, the victim's panties, panty hose.

Prosecutor: I have no further questions, Your Honor.

The court: "Mr. Hayes, do you have any questions for the witness?

Mr. Hayes: Yes, sir, Your Honor, I do.

Mr. Hayes (on cross-examination): Dr. Ralwing, when Mrs. Peters was brought in to see you, were you informed of the time that this rape against Mrs. Peters was supposed to have occurred on August 9?

Dr. Ralwing: Yes, sir, I was informed that this rape had occurred between the hours of 6:30 a.m. and 7:00 a.m."

Mr. Hayes: If I am not mistaken, so correct me if I am wrong, but didn't you just say that our findings subsequently after your examination of Mrs. Peters reflected that she did not have sexual intercourse within forty-eight hours of your examination?

Dr. Ralwing: That's correct.

Mr. Hayes: Dr. Ralwing, can you tell me what time was it on August 9 when you examined Mrs. Peters?

Dr. Ralwing: I would say that it was around 10:00 a.m.

Mr. Hayes: Dr. Ralwing, can you explain to me how is it possible for Mrs. Peters to have been forceably raped and your findings within a forty-eight-hour period?

Dr. Ralwing: "Well, there are two possible scenarios. Either penetration did not occur or the perpetrator had a very small penis. This would make sexual intercourse hard to detect.

Mr. Hayes: Are you saying that actual penetration did not occur in this case?

Dr. Ralwing: I am saying that this is a possibility. However, I asked Mrs. Peters about penetration during my examination, and she said that she was sure there was penetration.

Mr. Hayes: I have no more questions, Your Honor.

CHAPTER 17

Houston Police Criminalist Testifies

Prosecutor: The state next calls Officer Keith Moore. Officer Moore, would you mind telling us how you are employed and what are your job functions?

Officer Moore: I am employed with the Houston Police Crime Lab. I am a forensic chemist. My job functions vary, however, I usually perform scientific examinations of certain types of evidence taken from a crime scene.

Prosecutor: Can you tell us exactly what type of scientific examinations that you do on evidence taken from a crime scene?

Officer Moore: Well, as an example, say for instance that on-duty officers have collected a victim's clothing from a murder scene, I will perform a scientific examination of this evidence for the purpose of finding evidence that will identify the murder suspect.

Prosecutor: How accurate are your scientific examinations of the collected evidence?

Officer Moore: Well, it depends on the condition of the evidence. If the evidence is in good condition, my examinations are about 99 percent accurate."

Prosecutor: Do you conduct scientific examinations on evidence gathered from rape victims?

Officer Moore: Yes, sir, I do all the time.

Prosecutor: Do you recall obtaining clothing of a rape victim Mrs. Audrey Peters on August 9 of this year?

Officer Moore: Yes, sir, I recall obtaining clothing of a rape victim Mrs. Audrey Peters on August 9 of this year. (See fig. 2.) Yes, sir, I recall on August 9 of this year at approximately 12:00 p.m., Officer Newcomb bringing to my office the clothing (victim's panties, panty hose, and dress) of a Mrs. Audrey Peters who had been sexually assaulted that same morning.

Prosecutor: And did you happen to do any type of scientific examination on Mrs. Peters's clothing?

Officer Moore: Yes, sir, I did.

Prosecutor: What were the findings of your examination of Mrs. Peters clothing?

Officer Moore: Well, on the panties and panty hose, I found several strands of hair. Additionally, on the panties, panty hose, and dress I found substance of sperm.

Prosecutor: What did you do after you came up with your findings?

Officer Moore: At first, I closely ran tests on the sperm to determine if this was male semen. After I determined that the sperm was in fact male sperm, I contacted Mrs. Peters and I asked her if she had had sexual intercourse with a husband and/or boyfriend within the last forty-eight hours. She told me that she had not had any sexual intercourse with her husband within the last forty-eight hours. She said that she did not have a boyfriend. I then informed Mrs. Peters that I would need several strands of her hair, so that I could run tests to determine if the hair found on her panties and panty hose was hers or that of someone else."

Prosecutor: Did Mrs. Peters provide you with the strands of her hair for testing?

Officer Moore: Yes, she did.

Prosecutor: And what was the conclusion of your comparison with Mrs. Peters's strands of hair and the hair that you had taken from her panties and panty hose?

Officer Moore: I determined that several of the hairs found on Mrs. Peters's panties and panty hose were hers. However, I also determined that several other strands of hair were foreign hair, which was not hers.

Prosecutor: So would I be correct in saying that the male sperm and foreign hair found on Mrs. Peters's clothing could have come from the rape suspect?

Officer Moore: I would say that it is likely that the sperm and foreign hair did in fact come from the rape suspect.

Prosecutor: But how could you be sure about this conclusion?

Officer Moore: First of all, Mrs. Peters said that she had not had sexual intercourse with her husband within a forty-eight-hour period. The semen stains that I tested that were on Mrs. Peters's clothing were recent. At least within the last twenty-four hours. And the foreign hairs were that of someone other than Mrs. Peters. The chances are very good that those strands of hair came from someone who was engaged in sexual intercourse with Mrs. Peters.

Prosecutor: Officer Moore, inside this plastic bag, I have a pair of panties that are labeled with a Houston Police Department emblem and a signature. Can you identify this?

Officer Moore: Yes, sir, I can. These are Mrs. Peters's panties, the ones that I conducted the tests on.

Prosecutor: Inside this plastic bag, I have a pair of panty hose with the same HPD emblem and a signature. Can you identify this evidence?

Officer Moore: Yes, sir, the panty hose are the same ones that I conducted the tests on, which also came from Mrs. Peters.

Prosecutor: Can you identify this dress inside this plastic bag with the same HPD emblem and signature?

Officer Moore: Yes, sir, this is Mrs. Peters's dress, which I also conducted tests on.

Prosecutor: Can you tell me the name of the person that signed their signature to this evidence?

Officer Moore: Yes, that is my signature on all three plastic bags.

Prosecutor: I have no further questions, Your Honor.

Mr. Hayes (on cross-examination): Officer Moore, you previously testified that you conducted a thorough and exact scientific examination of Mrs. Peters's clothing. Is that correct?

Officer Moore: Yes, sir, that is correct.

Mr. Hayes: And would you mind telling me again about the conclusions that you reached pertaining to the sperm stains and foreign hair strands?

Officer Moore: My conclusions were that the hair strands taken from Mrs. Peters were not hers and that of someone else. And the sperm was that of a man.

Mr. Hayes: And didn't you also say that you were very sure that the foreign hairs and sperm came from the rape suspect?

Officer Moore: Yes, I did say that and I stand by that conclusion.

Mr. Hayes: Officer Moore, would there be any type of way where you could utilize some form of testing procedure on the defendant and make comparisons with the foreign hairs and sperm to determine whether or not the defendant was in fact the person that raped Mrs. Peters?

Officer Moore: As a matter of fact, there is a scientific procedure that could be conducted, which would allow me to make comparisons with the foreign hairs and sperm taken from the victim's clothing.

Mr. Hayes: What would this procedure be called and how would it be conducted?

Officer Moore: Well, we don't have no special type of name for our procedural testing. This is just forensic examination. However, if I had several strands of hair and a sample of blood from the defendant, I would be able to test the hairs and blood to determine whether or not there is a match with the foreign hairs and sperm taken from the victim's clothing.

Mr. Hayes: So are you saying that if this procedure was conducted, you could accurately determine whether or not the sperm and foreign hairs came from the defendant or that of someone else?

Officer Moore: That's exactly what I am saying.

Mr. Hayes: How long would this procedure take?

Officer Moore: About two, maybe three days at the most.

Mr. Hayes: And would you be willing to perform this procedure should the court allow it?

Officer Moore: Yes, I would.

Mr. Hayes: I have no further questions for this witness, Your Honor.

Prosecutor: The state rests its case, Your Honor.

CHAPTER 18

Final Day of My Trial —December 19, 1979

Mr. Hayes: Your Honor, before I call my first witness, I would like to present this motion to the court.

The court: What is your motion, Mr. Hayes?

Mr. Hayes: I would like to motion the court to allow forensic scientific testing to be performed, which would require the testing to be performed, which would require the taking of blood samples and strands of hair from the defendant for the purpose of matching this evidence with the foreign strands of hair and sperm stains from the victim's clothing to determine whether or not the defendant is the rapist or not. (See fig. 3.)

The court: Mr. Hayes, it appears that you are making this particular motion very later in the proceedings. Is there a reason for your late presentation of this particular motion?

Mr. Hayes: Your Honor, I didn't know that a forensic test could be performed on the victim's clothing, which would result in a finding that the sperm and foreign hairs taken from that clothing could be that of the person that really raped Mrs. Peters until I heard the testimony of Officer Moore yesterday.

The court: And what do you hope to get out of having this forensic scientific testing done?

Mr. Hayes: My client contends that he is innocent of this crime, and the forensic scientific testing could prove that my client is not the person who committed this rape. Additionally, Officer Moore

testified that this procedure would only take two to three days, which would not delay this trial for an undue period of time.

The court: I will deny the motion. You may call your first witness, Mr. Hayes.

Mr. Hayes: I would like to call the defendant, Synnachia McQueen Jr., to the witness stand.

Mr. Hayes: Mr. McQueen, you heard the testimony of Mrs. Peters in this case. Tell me, did you rape her on August 9, 1979?

Mr. McQueen: No, sir, I did not.

Mr. Hayes: Prior to December 17 when this trial began, had you previously seen Mrs. Peters before?

Mr. McQueen: No, sir, I have never seen her.

Mr. Hayes: Mr. McQueen, do you know where the Sheltering Arms is located?

Mr. McQueen: Yes, sir, it's about fifteen to twenty blocks from where I live.

Mr. Hayes: Are there times when you have to pass by Sheltering Arms?

Mr. McQueen: Yes, I sometimes pass by the Sheltering Arms on my way home from work. Because sometimes I catch the bus from work and the bus drops me off several blocks from Sheltering Arms.

Mr. Hayes: *How* often do you usually pass the Sheltering Arms?

Mr. McQueen: Not very often. I usually *get* a ride home from work. Other times, depending on when I get off of work, I would catch another bus that drops me off right in front of my house.

Mr. Hayes: Did you happen to go by the Sheltering Arms on August 9th of this year?

Mr. McQueen: No, sir.

Mr. Hayes: Do you know where you were around 6:00 a.m. to around 7:30 a.m. on August 9th?

Mr. McQueen: *No*, sir, I do not. But I believe that I was at home.

Mr. Hayes: What time do you usually get off work?

Mr. McQueen: I usually get off work around 4:00 or 5:00 a.m. However, I work a lot of overtime, so there are a lot of times when I get off of work around 8:00 or 9:00 a.m. in the morning.

Mr. Hayes: What time do you go to work?

Mr. McQueen: I have to be at work at 7:30 p.m.

Mr. Hayes: So are you saying that you don't know exactly where you were on the morning of August 9th?

Mr. McQueen: That's correct! I don't make it a habit of keeping up where and when I am at a certain place, unless it is important.

Mr. Hayes: On the morning of September 27, 1979, can you tell me why you ran from the police?

Mr. McQueen: Well, I was coming from this dope house when this policeman and this black guy approached me in a police car. The police officer and the black guy jumped out of the car, and the police officer told me to stop. However, I took off running, because the black guy had earlier that morning made an attempt to run over me with his car and I also had in my possession a bag of marijuana.

Mr. Hayes: Are you saying that you didn't want to get caught with the bag of marijuana, so you took off running when the police officer told you to stop?

Mr. McQueen: Yes, sir, that is correct. I was currently on probation, and I didn't want my probation revoked.

Mr. Hayes: So your reasons for running from the police had nothing to do with you raping Mrs. Peters?

Mr. McQueen: No, sir.

Mr. Hayes: Mr. McQueen, do you own a gun?

Mr. McQueen: No, sir.

Mr. Hayes: Did the police officers who arrested you make any attempt to find a gun on you or make a search where you lived?

Mr. McQueen: When I was arrested by the officers, they asked me if I had a gun. And I told them no. One officer searched me, but he found no gun. I also gave the officers my home address, but to my knowledge no one ever went to my house to search for a gun.

Mr. Hayes: Do you live with someone?

Mr. McQueen: No, sir, I had my own apartment. I lived alone.

Mr. Hayes: Did you rob Mrs. Peters of her watch on August 9th?

Mr. McQueen: No, sir, I never saw Mrs. Peters before in my life. Nor would I need to rob Mrs. Peters or anyone else for that matter. I had a very good job.

Mr. Hayes: Where were you working?

Mr. McQueen: I was working for Carnation Milk Company.

Mr. Hayes: And were you working on August 9th?

Mr. McQueen: Yes, I was working there until I was arrested on September 27.

Mr. Hayes: How much money did you make there?

Mr. McQueen: I was paid $250 to about $300 a week. However, most of the time I made more money, because I worked a lot of overtime.

Mr. Hayes: Did you have any outstanding debts and/or any bills that you hadn't paid anytime before August?

Mr. McQueen: No, sir, I didn't owe anyone any money. My bills were always paid on time. Also I was saving $50 a week out of my check and placing this money in the credit union at my job.

Mr. Hayes: How much money did you have saved up?

Mr. McQueen: A little over $200. I had just started putting money in the credit union several weeks prior to my being arrested.

Mr. Hayes: Did you say a little over $2,000?

Mr. McQueen: No, I said a little over $200.

Mr. Hayes: Oh, I see.

Mr. Hayes: Mr. McQueen, how long have you had that gold tooth in your mouth?

Mr. McQueen: About six or seven years. I got it when I was about fifteen years old.

Mr. Hayes: What type of gold is that?

Mr. McQueen: It's a solid plate of gold.

Mr. Hayes: You previously told me that sometime around August 9, 1979, you were wearing bandages on your face. Can you tell me what happened to cause you to wear bandages?

Mr. McQueen: On July 30 or 31st, myself and my girlfriend were waiting on the bus right next to the apartments where I lived. I was going to go and report to my probation officer when I was assaulted with a baseball bat by two black men. As a result of this assault, I had to wear bandages on my face for several weeks.

Mr. Hayes: Did you have to go to the hospital as a result of this assault?

Mr. McQueen: Yes, sir, the ambulance took me to Ben Taub hospital. However, I left without receiving any treatment, because I had waited for over an hour and no one had attended to me.

Mr. Hayes: For about two weeks after the assault. And then when I took the bandages off, I had several noticeable scars and bruises on my face for another couple weeks.

Mr. Hayes: Do you know who the people were who assaulted you?

Mr. Hayes: No, sir, I didn't know them.

Mr. Hayes: Do you know Mrs. Malveaux, who testified that you attempted to rape and rob her on September 27, 1979?"

Mr. McQueen: "Yes, sir, I know her. However, I have never made any attempts to rob and rape her on any date.

Mr. Hayes: Where did you know her from?

Mr. McQueen: I know her from school. We attended the same high school.

Mr. Hayes: And when did you realize that you knew who she was?

Mr. McQueen: When she was on the stand testifying. I immediately told you that I knew her from somewhere, but I could not remember from where. That's why I asked you to ask her what schools did she attend.

Mr. Hayes: Were you and her friends or enemies at school?

Mr. McQueen: No, to the best of my knowledge. I just recalled seeing her around school. I think that she and I even took several classes together.

Mr. Hayes: Do you know your whereabouts on September 27, 1979?

Mr. McQueen: Yes, sir, I was at my house with my girlfriend (Pam) and our daughter. I can recall this because this was two days before my arrest, and it was also on my payday. So I had Pam and my daughter staying the entire week with me.

Mr. Hayes: Mr. McQueen, prior to going before the lineup can you recall the detectives informing you that you had the right to counsel?

Mr. McQueen: Yes, sir, I can recall one of the detectives telling me this. He told me that if I wanted to waive my right to counsel that I could, and he said that if I was not picked from the lineup by anyone that I would be allowed to go home.

Mr. Hayes: Once the detective told you that if you were not picked in the lineup by anyone, you would be allowed to go home, you agreed to sign the waiver of the presence of an attorney?

Mr. McQueen: Yes, sir, because I honestly believed that I was not going to be picked out of a lineup by anyone.

Mr. Hayes: How did the other guys in the lineup with you look?

Mr. McQueen: Well, some of them were short, while several of them were taller than me. Some were fat and some were skinnier than me.

Mr. Hayes: Do you recall any of them resembling you in appearance?

Mr. McQueen: No, sir, as a matter of fact, not one of them was light complexion with a gold tooth like myself.

Mr. Hayes: You mentioned earlier that you were on probation. What were you on probation for?

Mr. McQueen: I was on probation for the unauthorized use of a motor vehicle.

Mr. Hayes: How long had you been on probation?

Mr. McQueen: I was given a four-year probation sentence. However, I was scheduled to come off probation on September of this year.

Mr. Hayes: If you hadn't been arrested for this crime, you would have successfully completed your probation period?

Mr. McQueen: Yes, sir.

Mr. Hayes: Have you ever been in trouble with the law other than the unauthorized use of a motor vehicle?

Mr. McQueen: Yes, sir, I had a misdemeanor for possession of marijuana when I was in high school. I completed that probation successfully.

Mr. Hayes: Any other type of trouble with the law?

Mr. McQueen: No, sir. Other than when I was a juvenile, I was arrested for trespassing on a couple of occasions.

Mr. Hayes: Were you committed to juvenile detention for those offenses

Mr. McQueen: No, sir, I was released to my father.

Mr. Hayes: Do you know why Mrs. Peters is saying that you are the man who attacked and assaulted her on August 9th?

Mr. McQueen: No, sir, the only thing that I can figure is that she is mistaking me for someone else.

Mr. Hayes: Mr. McQueen, you heard the testimony of Officer Moore and what he said about the forensic scientific testing. Would you be willing to submit your blood samples and strands of your hair, so this procedure could be conducted?

Mr. McQueen: Yes, sir, I would, especially since it could prove that I am innocent.

Mr. Hayes: I have no more questions, Your Honor.

Prosecutor (on cross-examination): Mr. McQueen, you testified that you were running from the police, because you had marijuana in your possession. Is that correct?

Mr. McQueen: Yes, sir, that is true.

Prosecutor: What happened to the marijuana?

Mr. McQueen: I threw it away.

Prosecutor: So the police didn't find the marijuana on you?

Mr. McQueen: No, sir.

Prosecutor: Did you also throw away the gun that you had on you?

Mr. McQueen: What gun? I never had any gun in my possession.

Prosecutor: Mr. McQueen, you also testified that you had eluded the police who were chasing you, and in the process you got rid of the marijuana that you had in your possession. Therefore, you also had time to get rid of the gun as well. Isn't that also correct?

Mr. McQueen: I never had no gun in my possession to get rid of.

Prosecutor: Mr. McQueen, you testified that you did not want to get caught with the marijuana, because you were on probation. Is that true?

Mr. McQueen: Yes, sir.

Prosecutor: Mr. McQueen, didn't you know that being in possession and using marijuana was a violation of your probation?

Mr. McQueen: Yes, I knew that.

Prosecutor: Why did you do it?

Mr. McQueen: I don't know, I guess that I was being dumb.

Prosecutor: Were you also being dumb when you forcibly raped Mrs. Peters on August 9th?

Mr. McQueen: No, because I never raped Mrs. Peters. Until I came to court, I had never seen Mrs. Peters before in my life.

Prosecutor: Mr. McQueen, you testified that you lived a few blocks from the Sheltering Arms. Is that correct?

Mr. McQueen: I lived about fifteen to twenty blocks from there.

Prosecutor: And you said that you occasionally passed by Sheltering Arms on your way home from work. Isn't that also correct?

Mr. McQueen: Yes, sir.

Prosecutor: And you previously said that you did not know where you were between 6:00 and 7:00 a.m., on August 9, 1979. Is that correct?

Mr. McQueen: Yes, sir, that is correct.

Prosecutor: Mr. McQueen, you can't really say for certain that around 6:00 or 7:00 a.m., on August 9, 1979, that you were not passing by or even on the premises of the Sheltering Arms?

Mr. McQueen: Yes, sir, I can say for certain that I know that I was not at or near Sheltering Arms on August 9, because I didn't catch the bus from work at no time during the month of August.

Prosecutor: I have no more questions for this witness, Your Honor.

CHAPTER 19

Testimony of My Probation Officer

Mr. Hayes: I would like to call Mrs. Kathy Fleming to the stand. Mrs. Fleming, could you tell me what your job description is?

Mrs. Fleming: I work for the Houston Probation Department.

Mr. Hayes: How long have you been employed with the Houston Probation Department?

Mrs. Fleming: About five years.

Mr. Hayes: Do you know the defendant in this case, Mr. Synnachia McQueen Jr.?

Mrs. Fleming: Yes, sir, I do.

Mr. Hayes: Can you tell me how you know this defendant?

Mrs. Fleming: He was one of my probationary felons.

Mr. Hayes: So you were his probationary officer?

Mrs. Fleming: Yes, sir.

Mr. Hayes: Can you tell me what type of probationary person Mr. McQueen was?

Mrs. Fleming: He was actually a good probationary person. He always reported on time, and he always paid his probation fees on time. I can only recall having problems with him on one occasion.

Mr. Hayes: What type of problems did you have with him?

Mrs. Fleming: Actually it was only one problem, and it wasn't a big problem. He missed one of his scheduled appointments with me. He said that he had been assaulted with a baseball bat by several men and therefore he couldn't make the appointment.

Mr. Hayes: Mrs. Fleming, can you recall when this appointment was supposed to take place?

Mrs. Fleming: Around the end of July.

Mr. Hayes: Was that the only appointment that he missed with you?

Mrs. Fleming: Yes, sir. That was the only time that he ever missed one of our scheduled appointments. However, he did call me later and explained his situation.

Mr. Hayes: How long had you been seeing Mr. McQueen?

Mrs. Fleming: For about a year. He had a four-year probationary sentence. However, with good reporting, staying out of trouble, and the payment of his probation fees, he would have been getting off probation in October of this year.

Mr. Hayes: Mrs. Fleming, did Mr. McQueen ever display any type of violence, anger, and/or disrespect towards you or while he was in your presence?

Mrs. Fleming: No, sir, as a matter of fact, Mr. McQueen was just the opposite. He was always respectful, attentive, and responsible when he came to see me.

Mr. Hayes: When you heard about Mr. McQueen being charged with rape, what did you think?

Mrs. Fleming: I was shocked, because he had never acted like he was capable of committing such a crime.

Mr. Hayes: I have no further questions, Your Honor.

Prosecutor (on cross-examination): Mrs. Fleming, how often did you see the defendant?

Mrs. Fleming: Once a month during our scheduled visits.

Prosecutor: Where did these meetings take place?

Mrs. Fleming: At my office on San Jacinto.

Prosecutor: Did you ever have any home visits with Mr. McQueen?

Mrs. Fleming: No, sir, I did not. The one time that he missed his appointment I did go by his apartment, however, he wasn't home. And I believe that I went by there on another occasion, but he was at work.

Prosecutor: So your knowledge of Mr. McQueen is based on the visits that he had at your office on a monthly basis. Is that correct?

Mrs. Fleming: Yes, sir, that is correct.

Prosecutor: So you did not know the defendant that well?

Mrs. Fleming: About as well as my job would allow me to know someone on probation under my supervision.

Prosecutor: So you can say for certain that you knew the defendant well enough to say that you know that he wasn't capable of committing robbery and rape?

Mrs. Fleming: No, sir, I can't say this for certain. All I can say is how he presented himself when he was in my presence.

Prosecutor: Your Honor, I have no further questions.

Mr. Hayes: The defense rests, Your Honor.

The court: "Okay, I will recess for lunch, and I will make my decision on the defendant's guilt or innocence.

Subsequently after Mr. Hayes informed the court that he would rest, I asked him about my witness, Ms. Pamela Knoxson. Mr. Hayes told me that he had subpoenaed Ms. Knoxson, but he said that she didn't show up for trial. However, Mr. Hayes never informed the court that he had a witness who did not appear, nor did he ask the court for additional time to procure the presence of this witness.

Approximately one hour and thirty minutes later, I was escorted from the holding cell back into the courtroom. When I reached the courtroom Mr. Hayes told me that the judge had made his decision.

The court: Will the defendant rise. After hearing the evidence submitted by the prosecution and the defense, I hereby come to the conclusion that the defendant is guilty of the offense of aggravated rape.

CHAPTER 20

Presentence Investigation Prior to Final Sentencing

Mr. Hayes: Your Honor, prior to sentencing, the defense is requesting that a presentence investigative report be conducted to aid in determining the appropriate sentence for the defendant.

The court: Does the state have any objections to a presentence investigative report for the defendant?

Prosecutor: No, sir, the state does not object, Your Honor.

The court: I will adjourn until thirty days from today to allow a presentence investigative report to be conducted and completed and returned to this court prior to my determining the appropriate punishment for the defendant.

My world was in a whirlwind. I felt as though I was on the verge of getting the death penalty. Mr. Hayes had told me not to worry about anything. He said, "With your past criminal background, you should receive a short sentence." However, I had felt betrayed. It was my ultimate understanding that your trial lawyer was supposed to do any and everything legally for his client during the course of the trial to ensure that his client was found not guilty. I especially felt betrayed and wronged in my case, because I knew for a fact that I had not committed this crime and I was absolutely innocent. Even as a layman with not very much understanding of the law, I knew deep down in my heart that my attorney had not presented a defense in my behalf which would have ensured the opportunity to be found not guilty.

SILENCED BUT DETERMINED

As I was sitting in the courthouse holding cell, the events that had occurred in my trial were constantly pounding inside my head. While I was in deep thought, one of the other pretrial detainees (someone awaiting trial, but he had not been convicted of a crime yet) sat next to me. He asked me, "Are you all right?"

I just shook my head as if to say no.

He said, "Man, tell me, what happened to you in court today?" Additionally, he said, "I am scheduled to have my trial today in the same court that you were in." (I don't know whether or not he thought about his statement before he said it because everyone in this particular holding cell was assigned to have their cases heard in the 232nd.)

Finally, the pressure became too much for me and I began crying. I stated in a high-pitched voice, "Man, I just got found guilty for something I did not do."

The detainee said, "What? How did this happen?"

I said, "Man, I'm not sure, but I believe that my court-appointed attorney sold me out."

He asked, "What type of case did you have?"

I hesitated at first, because telling people that you are a convicted rapist doesn't go well with everyone in jail and in prison. However, I told him, even though I said it in a very low voice, so the other two guys waiting in the holding cell couldn't hear me.

He asked me, "Did you have a jury trial?"

I said no. I told him, "I feel as though I would have had a better chance with a jury that with a judge."

He said, "Man, why didn't you have a jury trial?"

I told him that my attorney had told me that if I waived my right to a jury trial that he could possibly get me probation, that is, if I had been found guilty.

He said, "Man, check this out. I know the law, this is my third fall. I said that to say this, if you were charged with rape and it was aggravated rape"—I shook my head yes—"man, you were not even eligible for probation." He said, "Now I've seen these types of things work out if you are going under the table. "Did you go under the table?"

97

I asked him, "What do you mean by under the table?"

He said, "This is when you pay your lawyer a certain amount of money and he works out a deal with the judge and prosecutor to make sure that you are given a certain short sentence."

I said, "Man, my attorney was court appointed, therefore I didn't have any money to pay him for representing me."

He then said, "Well, it just don't pan out, your attorney persuading you to waive your right to a jury trial in such a serious case as this." He stated, "I can only tell you one thing, and that is your lawyer was working with the state and he definitely sold you out." He asked me, "How much time did you receive?"

I told him that the judge hadn't given me any time yet. I informed him that my case had been adjourned for thirty days while a presentence investigative report was being conducted.

He asked, "Why are they doing a presentence investigation report on you?"

I told him, "Because my attorney asked the judge for one prior to the assessment of my punishment."

He then asked, "What was your attorney's name?"

I told him, "Ronald N. Hayes."

He said, "I've never heard of him." He further stated, "However, from now on, I will remember that name, because, man, he totally fucked you and then some." He said to me, "You better watch out, you might end up getting fifty years to life from a judge."

I said, "Yeah, man, I don't like the way things went down."

He asked me, "Do you know anything about the law?"

I told him, "No, nothing whatsoever."

He said, "Well, I either suggest that you learn or you find a writ writer to help you."

I said, "I don't know anyone who is a writ writer."

He asked me, "What tank do you live on?"

I told him that I lived on 3D1.

He stated, "Man, there are quite a few people that are knowledgeable in the law on the tank that you live on." He further stated, "Most of those guys who live on 3D1 have been down two, three, and maybe even more times."

I said, "Man, I don't know, because it's hard telling other people what I am locked up for."

He said, "Man, those dudes on 3D1 are hardcore criminals, rapists, murderers, robbers, and even child molesters."

I said, "Well, I guess that I don't have any other choice, because I don't have any family support."

He stated, "Man, I'm in the same boat. From day one during my first time in prison, my family cut me off from any and all support and love. So I have been going it on my own ever since." He finally said, "This is my third time looking at doing time in the Texas pen. But my limited knowledge of the law has helped me from getting long sentences. Hopefully my luck hasn't ran its course this time, because I am a habitual offender. Therefore I could possibly get life in prison if I don't play my cards right."

I asked him, "Do you have a paid attorney?"

He said, "No, I have a court appointed attorney. But he don't do anything, except for what I tell him to do." He showed me the inside of a folder that he was carrying and he said, "Inside this folder, I have numerous motions and notes that I use. I tell the attorney what to say and what to file. So if I get slammed, it will be on my own mistake(s). And I could live with that." At that moment the bailiff came to get him to escort him to court.

After he exited the holding cell, I pulled myself into one of the empty corners and cried myself to sleep. Several hours later, he returned. Once the holding cell door was open, I immediately woke up. He came in with a smile on his face, and he sat down right next to me. I said, "Why are you smiling, did they let you go?"

He said, "No, but I picked the jury, and the prosecutor is now offering me an aggravated five to twenty years." (If a case is aggravated, the convict must serve one-third of his sentence to become eligible for parole.)

I said, "Man, that ain't bad under the circumstances, that is, if you are guilty."

He said, "I am guilty, and twenty damn sure beat a life sentence. But by the time trial begins next week, I will have it down to five to fifteen, just watch."

Several months after our initial conversation, I would see and talk to my friend again (I later found out that his name was Ray) while I was working in the rehab. I had a job going around to each tank and taking off the indoor screens, thereafter taking the screens to the back dock where myself and several other inmates would wash them and then we would replace the screens back on the windows.

Anyway, Ray told me that he did in fact persuade the prosecutor to give him the fifteen-year sentence, and now he was just waiting to go to prison. His final words were "I can't wait to get back home."

About a week after my conviction, I was able to get in contact with Pam via telephone, and I asked her why didn't she come to my trial and testify in my behalf. Pam told me that she didn't know when and where to come to. She said, "I never received any subpoena, nor did your attorney get in contact with me, other than the time his secretary had called me and asked me if I would be willing to testify for you at your trial."

Two weeks after I was convicted, a guy from the Houston Probation Department came to the rehab for the purpose of interviewing me. He asked me numerous questions about my personal and criminal background. While I was giving him this information he was writing it down. Subsequently after our interview he stated, "I don't know why you are being given a presentence investigation report for probation. You're not eligible for probation." I told him, "This is what I was led to believe from my attorney. However, the judge said that the presentence investigation report is to aid in determining the appropriate sentence for me."

While awaiting my sentencing, I began to study the law. A couple of the other inmates would help me. However, most wanted to be paid, and since I figured that I needed to help myself, combined with the fact that I was low on money, I picked up a few bits and pieces here and there. One thing was for certain; each person that I had conferred with pertaining to the manner that my trial was conducted unanimously agreed that I had been shafted by my court-appointed attorney. And several other fellows offered the possibility that maybe even the prosecutor was involved as well. Most of these individuals reached this conclusion after I told them about my conversation

with my attorney prior to waiving my right to a jury trial and the fact that the prosecutor was present when he was feeding me all this bull about the possibility of getting me another probation from the judge should I be found guilty. It was also unanimous among the fellows that I had good grounds for a new trial. Several individuals informed me that I should request a new trial at the final sentencing proceeding.

CHAPTER 21

The Plan

With some assistance, I had mapped out a plan that when I attend the final sentencing stage of my trial that I would submit a verbal and written motion for a new trial based on the following factors: I had been denied my right to a jury trial based on false information from my attorney; I had been denied the right to a fair trial and the right to have my witness testify in my behalf to relevant facts that would aid me in my trial, due to the failure of my attorney to secure my witness attendance at trial; and I received ineffective assistance of counsel during my trial.

I had also reached the conclusion that I would not share my contentions with my attorney, but I would fill him in on a few of my allegations for a new trial.

Sometime during January 1980 (actual day unknown), I was transported back to the Harris County Courthouse for the purpose of the punishment being assessed. I was escorted to the holding cell where I remained from about 8:00 a.m. to 4:30 p.m. At approximately 1:00 p.m., Mr. Hayes came to the holding cell and told me that Judge Guyon had taken ill and the assessment of punishment hearing would be rescheduled to another date. Again on a day in January, I was taken back to the Harris County Courthouse for the punishment hearing. However, the date was rescheduled again, because Judge Guyon was supposedly ill.

On February 14, 1980, I was once again transported back to the Harris County Courthouse for the punishment hearing. I was subsequently placed in the holding cell. However, I was informed that

Judge Guyon still wasn't available, so the punishment hearing would be rescheduled to another date. *Note*: I did not know the specific dates in January that I was transported back to the courthouse, but I definitely remembered February 14, because this was on Valentine's Day. The extra time that I was getting, before my opportunity to go back before the judge, was being spent gaining knowledge of the law. Even though many things were very confusing, I was beginning to get an idea about what had actually transpired in my original trial. It had become obvious to me that my attorney had acted with the prosecution to ensure that I was convicted. My defense was totally inadequate, and with this defense I didn't have a chance to be found innocent. And to compound matters, my chances of being found innocent had significantly been reduced as a result of my having my trial before a judge and not a jury. Surely twelve minds reviewing the evidence is better than one in this type of case. As time continued to pass, I was beginning to wonder what had really happened. I was hoping (naturally this was a dreamlike hope) that possibly the judge was again reviewing the evidence submitted in my case and just maybe he would compel him to grant me a new trial. However, being in this situation with the thought of facing a number of years in prison created a false sense of hope and expectation.

Finally, on March 14, 1980, I was transported back to the Harris County Courthouse. Unbeknownst to myself, this day would be the beginning of a long journey of hell on earth. Subsequently after reaching the courthouse, I was placed in the holding cell. When we reached the holding cell, it was around 8:00 a.m. Time slowly passed on this day, and when the time reflected 1:30 p.m., I was beginning to think that this was another false trip. Then finally, the court officer (not the bailiff) came to the holding cell and called my name. I was instructed to get ready to go back into court. At approximately 2:00 p.m., the bailiff came to the holding cell and called my name. My heart literally jumped out of my chest. Even though this was a day that I had been waiting and hoping for, so that I could explain to the judge just how I had been wronged during this trial, it was also a day that I did not want to have to face. Because deep down in my heart, I knew that if I had been sentenced to prison, it would be the worst

day of my entire life to date. The tragic irony of my entire thought process at this point was that I was still hoping that the judge would sentence me to a probated sentence.

As I slowly approached the holding cell door, it seemed as though my mind was racing back in time in very slow motion. I could see the time when I was a little boy when I found $250. I could then see when I had the basket in a junior varsity basketball game that tied the score at the end of regulation. Then in overtime we eventually won the game. That was the only basket that I had hit. These events in my life hadn't really occurred that long ago. Right before I reached the door, I could see the faces of my three daughters crying for their daddy. When I reached the door, the bailiff asked me if my name was Synnachia McQueen Jr. (he couldn't correctly pronounce my first name), and I responded, "Yes, I am."

The bailiff told me that the judge was ready to see me. He also informed me that my attorney was already waiting in the courtroom. Wearing black pants and a green shirt that I believe were the same colors that I had worn each time I had went to court, I slowly walked in front of the bailiff into the courtroom. I looked around the courtroom, and it was practically empty, except for a man and a woman, whom I didn't know, sitting in the seating area of the court. I was escorted to the table where my attorney was, and the prosecutor occupied the table adjacent to where we were seated. When I faced the bench, I realized that this judge was not Judge Guyon. I didn't know what to think of this, nor did I have any idea as to what I was supposed to suspect.

CHAPTER 22

A New Judge Final Sentencing Me

The judge asked the prosecutor if he was ready. The prosecutor responded, "The state is ready, Your Honor." The judge then asked Mr. Hayes if he was ready. Mr. Hayes responded, "Yes, we are ready, Your Honor." The judge told me to stand up. Subsequently after I stood up the judge asked me if I had anything to say before he sentenced me. I stated that I had a request for a new trial. The judge instructed me, Mr. Hayes, and the prosecutor to approach the bench. After we approached the bench, Judge Patterson (a visiting judge and not the judge that was at my trial) asked me, "What is the basis of your motion?" Mr. Hayes spoke up and stated that he was bringing a motion for new trial based on the fact that the evidence was insufficient to support the conviction. Judge Patterson asked the prosecutor, "Counselor, do you have anything to say in opposition of this motion?"

The prosecutor stated, "The evidence in this case was sufficient to support the conviction. The victim picked the defendant out of a lineup several months after the crime, and she additionally identified the defendant during the trial as the man who had raped her on August 9, 1979."

Judge Patterson asked, "Was this case tried to the jury or the judge?"

The prosecutor responded, "The evidence and guilty/innocent stage of the trial was tried before Judge Guyon."

I then spoke up and I stated, "I want to make a motion for new trial based on newly discovered evidence."

Judge Patterson asked me, "What is this newly discovered evidence?"

I told Judge Patterson that evidence pertaining to my having bruises and/or scars on my face during the time that Mrs. Peters had been raped was never brought before the court. Additionally, I informed the judge that I had a witness who would have testified to my having these bruises and/or scars around the time that Mrs. Peters was assaulted, and this same witness had been my alibi witness on September 29, 1979, the date that I was to have supposedly robbed a Mrs. Malveaux. I told the judge that my attorney never did call my witness to testify in my behalf. The following colloquy took place.

Mr. Hayes: Your Honor, I did subpoena his witness, however, she didn't show up for trial.

Mr. McQueen: Your Honor, I recently talked to Ms. Knoxson, my witness, and she told me that she never received any subpoena, nor was she informed of the date to appear at my trial.

Prosecutor: Your Honor, this doesn't constitute newly discovered evidence.

Mr. Hayes: Your Honor, I've already explained this to the defendant.

Judge Patterson: At this time I will deny the request for a new trial. I would have to believe that Judge Guyon weighted the evidence and based his decision to find the defendant guilty on the preponderance of the evidence. The defendant's punishment in this case has already been assessed at forty years' confinement. Therefore, I will issue a final sentence of five to forty years confinement in the Texas Department of Corrections.

Mr. McQueen: Your Honor, I have not received any assessment of punishment. Judge Guyon recessed the assessment of punishment until a presentence investigation report could be completed, and this is the first time that I've been back before the court since December 19.

Judge Patterson: Well, the prosecution and your attorney have stipulated that your punishment has already been assessed at five to forty years' confinement.

Subsequently after hearing the judge say those words, I began hollering and screaming. The bailiff and a deputy sheriff immediately wrestled me to the floor and handcuffed me. These officials then escorted me back to a holding cell in the Harris County Jail. During this period of time (1980s), Harris County deputies were notorious for beating up prisoners who did not cooperate with them. As the bailiff was escorting me to the holding cell, one of the deputies asked, "Is he the one that was causing trouble in the 232nd Court?"

The bailiff responded, "Yes, he is the one that we had to wrestle to the floor and handcuff in the courtroom."

Another deputy said, "Don't worry, we'll take care of him."

The bailiff said, "No, don't harm him, because they really shafted him during and after his trial."

CHAPTER 23

Conviction and Final Sentence to Five to Forty Years in Prison

The only thing that I could think of was the fact that I would be spending the rest of my life in prison. My thoughts continued to pound the thought of forty years into my skull. I lay on the concrete floor of the cell and began crying and crying and more crying, until I just didn't have any more tears to shed anymore. Around 5:00 p.m., the transportation van arrived for the purpose of taking myself and eight other inmates back to the rehab. On the way back to the rehab, I basically stayed to myself giving out vibes that I did not want to be bothered. My mind-set was not lost on the other occupants of the van. There was a visible understanding among us prisoners that certain actions reflected a finding of guilt and a subsequent long-term sentence that had been handed down in court. After I arrived back at the rehab I immediately went to my bed and went to sleep. Again mostly everyone on my tank had intuitively knew what the deal was, so no one approached me.

 Several hours later, I woke from my slumber, and the thoughts that were racing through my mind were how my trial had been conducted and all I could think about was how from the very beginning my court-appointed attorney was out to get me convicted. But I continued to ask myself, "Why would he do this?" But from the

very beginning, convincing me to waive my right to a jury trial was definitely not in my best interest. How naive I had been by totally trusting my attorney. But the fact of the matter was that I was raised watching *Perry Mason* (popular television series) and I was convinced from this experience that your lawyer is your best friend in a situation like this. Plus in my two prior problems with the law, in both situations I had been given a probated sentence and had actually prevailed based on the lawyerlike decisions of my attorneys. That is, that's the way I had felt; that is, until I learned the law.

But this was nothing like my prior situations with the law, nor was it anything like I had imagined during the many times that I had watched *Perry Mason*. I could not put my finger on it. However, I knew that this lawyer had done me in for some unknown reason.

For the next couple of days I just waddled in hopelessness and depression. On the third day after my forty-year sentence I was approached by this convict (his name was old man Dan). Dan had already been to prison four other times, and he was now in the early stages of a life sentence. He was just waiting for his trip to the big house, and he sat next to me and asked if he could have a few words with me. I told old man Dan, "I'm not in the mood for talking right now."

Old man Dan said, "You know something, youngster, I had admired you, the way you had begun studying the law, fighting back, and taking on a task that many my age would not even consider doing. However, I can see that I had you pegged all wrong, you are just like all those other sorry ass youngsters who will be spending half of their lives in prison."

I did not say anything to old man Dan's sermon.

Old man Dan asked me, "How much time did they give you?"

I responded, "Forty years' aggravated." I said, "Man, I don't know to begin doing forty years in prison."

Old man Dan said, "Well, what are you going to do, cut your throat, hang yourself, not eat until you die, exactly what are your future plans?"

I said, "I don't have any intentions of hurting myself."

Old man Dan asked me, "Then what are your plans for the future?"

"Right now I don't see any plans" is what I told him.

He said, "Well, you need to do something, because time is not on your side, and if you intend on getting that forty years off your back, you need to start on it now."

Prior to this conversation with old man Dan, I had only spoken to him a few other times about the law and how difficult it was to learn all the different types of rules and procedures. I had never told him anything about my case. Old man Dan asked me, "Did you tell the court that you wanted to put your case on appeal?"

I told him about the incident that had occurred in the courtroom, whereas I had been handcuffed and forcibly escorted out of the court by the deputy and bailiff.

He asked, "So you don't know whether or not your case has been placed on appeal?"

I responded, "No, I do not."

Dan said, "Man, I don't want that type of experience to happen to you again, so I am trying to help you out, if I can."

I said, "Thank you!"

Dan said, "It's possible that your lawyer put your case on appeal for you."

I said, "Man, I don't want that sorry ass lawyer doing anything for me ever again."

Dan told me, "You will need to write an appeal in your case and that state that you would prefer another attorney representing you on appeal."

I asked Dan, "When should I do this?"

His response was "immediately."

Dan told me to tell him about my case and my trial from beginning to end. I reluctantly began telling him everything beginning with my arrest, the lineup procedures, my conversations with Mr. Hayes, Mr. Hayes's persuasion to convince me to waive my right to a jury trial, the evidence used against me, the presentence investigation report that was prepared, the happening of events at the request for new trial proceedings, the fact that a visiting judge had final sen-

tenced me to a term of five to forty years' confinement, because the visiting judge had said that Judge Guyon had already given me this sentence, which was falsely agreed to by Mr. Hayes and the prosecutor. When in fact I had never even gone before Judge Guyon for the assessment of punishment. The fact that Mr. Hayes had failed to subpoena my only witness when in fact Mr. Hayes informed the court that he did in fact subpoena my only witness and had her present. Dan asked me to repeat some of what I had just told him. After I again repeated a few of the happening of events that I had just mentioned to him, Dan said that he had never heard this happening in a trial before in his entire life. Dan asked me if I was lying to him. I told him no; this was the total truth.

Dan went on to say, "Man, I know what happened to you. Your attorney had to be working with the prosecutor to ensure that you were convicted. This is an election year, and these court-appointed attorneys and prosecutors will work together to get as many convictions as they can and to get as much time for convictions as they can get." He further stated, "And I wouldn't doubt it if the judge was in on this as well." He said, "I don't believe that this was a coincidence that you received the same forty-year sentence that the prosecutor had offered you in a plea bargain agreement." He continued, "Then there is the fact that you were not present for the assessment of punishment. You should have had an assessment of punishment and a presentence investigation hearing before the judge, and you should have been present at those hearings." Finally, Dan said, "I also don't see how a judge could stand by and allow you to waive your right to a jury trial in such a serious case as this."

I told Dan, "I still have two more cases that I need to go to court on."

Dan said, "What?"

I explained to him about my pending indictments in the cases pertaining to Mrs. Malveaux for attempted rape and robbery. I told him that this was the lady who was responsible for my being arrested in the first place, resulting in my being placed in two different lineups.

Dan asked me, "What type of evidence did the state have?"

I informed him that the state didn't have anything but the victim's identification and word that I was the one who had assaulted her. Additionally, I told him what had occurred when Mrs. Malveaux had testified in Mrs. Peters's case, whereas I immediately recognized her, and before she completed her testimony I recognized her as someone that I attended high school with. I finally told him that I had an alibi defense in this case.

Dan asked me, "Do you have a lawyer to represent you on these two cases?"

I responded, "As far as I know, Mr. Hayes is supposed to be my attorney in these two cases as well."

Dan told me, "You need to immediately inform the court that you want another attorney as soon as you arrive in court. Additionally, you need to explain to the court exactly what had transpired in your previous trial with Mr. Hayes representing you and the fact that you do not believe that you could ever receive fair representation with Mr. Hayes as your attorney."

I had now risen from my slumber, and I was writing down the information that Dan was conveying to me. Dan asked me, "Do you have any family members or friends that could hire an attorney for you?"

I responded, "The only person that I knew that may help me was my father." But my father was a person whom I hardly knew, nor did I know how to get in contact with him.

Dan said, "If I was you I would try to get in contact with your father, because you are going to need another lawyer to help you with those other two cases." He said, "In my opinion, you have a good chance to beat both of those cases, and if you don't, you may never ever see the free world again." Dan told me that he would help me all that he could while he was there, but he said that he would probably be going to the big house in a couple more months. He said that he would teach me many things about the law within that time period. Several weeks later, my income tax 240 form arrived from my job and Dan completed all the necessary forms and mailed the tax forms to the Internal Revenue Service.

CHAPTER 24

Applying Myself by Learning the Law

For the next several weeks, I began learning about the many different aspects of the law. Dan told me that the law had a gray area, but he said he doesn't know what a person would call the type of legal proceedings that occurred during my trial. Dan started teaching me the very basics, such as pretrial motions, the examination of the evidence from both parties' viewpoints, and he explained the ability to determine what evidence was more pervasive than the other party.

He explained the things that I should take notice in regard to my attorney and prosecutor when they are examining the witnesses. He told me when I should tell my attorney to object, which on most occasions would be objective, and he told me what to say to the court should something needed to be said. He explained a number of other things as well.

I suddenly realized that I still had almost $300 in the credit union at my job. So I decided to find out if I could find an attorney that I could hire with the $300 from the credit union combined with the money that I would be getting back from my income tax return, so this attorney could represent me on the two remaining cases. I broached this idea by old man Dan, and he thought that this was a good idea. However, he warned me not to get upset if I couldn't find someone to represent me at such a small amount of money. Dan stated that most lawyers don't handle the types of cases that I had remaining (attempt rape and robbery) without receiving a substan-

tial fee, possibly in the thousands. He told me that it was possible that a lawyer would take my case and get a dismissal of the charges. He stated that due to the fact that I had an alibi and I knew (even though vaguely) the victim Mrs. Malveaux, Dan suggested that I take a look in the telephone book (yellow pages) for listings of attorneys. He stated that I could possibly find an attorney that may be able to help me.

I did exactly what Dan had suggested, and I came upon the name of a Mr. Bozo Jr. (honestly this was his real name). I contacted Mr. Bozo Jr. by telephone, and I explained my financial situation to him. I also told him about the fact that I currently had $300 in the credit union at my job, additionally with my expectation that I had an additional $300 coming in from my income tax return. I also informed him that my daughter's mother may be able to aid financially as well. I thereafter gave him my daughter's mother's telephone number, and I asked him to contact her. About a week after my conversation with Mr. Bozo Jr., old man Dan left heading to the big house. Before leaving, he told me to never give up. He said, "From everything that you have told me about what transpired before, during, and after your trial, I honestly believe that at some point you will eventually get a new trial." His last words were "I am positive about this."

Without old man Dan around to help me along, I felt a little lost and very alone. However, I continued to apply myself with taking care of my ultimate goal, which was being able to learn the law to a degree where I would be able to make a valid stand in the courts. I had spoken to Atty. Bozo Jr. on several more occasions, and he informed me that my daughter's mother said that she wouldn't be able to pay him any money to represent me. However, he told me not to worry about that right now. He said that he was going to contact the court to find out when I would have my next court appearance. He stated that he would try to be there in court on the date of my appearance. He said, "At that time I will request the judge to appoint me [speaking of himself] to represent you on these two remaining cases."

Exactly one week after I had this conversation with Atty. Bozo Jr., I was summoned back to court. Subsequently after arriving at the courthouse, Atty. Bozo Jr. came to the holding cell to speak to me. He told me that he was going to ask the judge if he could represent me as a court-appointed attorney. He said, "In a few hours, you will be brought before the judge to confirm this." In about another hour, Atty. Bozo Jr. came back to the holding cell and informed me that he had talked with the judge and the judge had told him that I was already being represented in the Malveaux cases by Atty. Hayes. I told him that I would greatly appreciate it if he would go back before the judge and tell the judge that I said under no circumstances do I want Mr. Hayes representing me. I then asked Atty. Bozo Jr. to inform the court that I was asking the court to appoint him (Mr. Bozo) as my attorney.

He stated that he would inform the judge of my requests. About another hour later, Atty. Bozo Jr. came back to the holding cell and told me that the judge had not taken any action on my requests. Atty. Bozo Jr. said that the court scheduled my case for another date. He told me that he would definitely be there for my next court appearance.

CHAPTER 25

Dismissal of Remaining Charges

Several hours later, the bailiff came to the holding cell and informed me that the prosecutor (Chris L.) wanted to see me. The bailiff escorted me to this room where the prosecutor (same one who prosecuted me at my first trial) and Atty. Hayes were present. I was instructed to take a seat by the bailiff. After I took a seat, Mr. Hayes told me that the prosecutor was going to dismiss the two remaining cases against me. Additionally, Mr. Hayes informed me that he had requested an appeal in the other case. I didn't say anything to this revelation. I just shook my head as though I was in approval with information that I was given to me. For several minutes, there was silence in the room, and Mr. Hayes and the prosecutor were just staring at me. Mr. Hayes broke the silence by saying, "That will be all for now." The bailiff reentered the room and proceeded to escort me back to the holding cell.

The revelation about the two remaining cases pending against me being dismissed were a substantial load off my mind. But I immediately reminded myself that the fight for my freedom was many years ahead.

In my mind, I played back the events that had occurred earlier in the day. From the very beginning, beginning with my visit with Atty. Bozo Jr., along with my subsequent meeting with Mr. Hayes and the prosecutor, I felt that something just wasn't right. I had given

long thought to what had transpired, and I had a strong belief that something just wasn't right.

I asked myself, "Why did the prosecutor all of a sudden dismiss the remaining charges (attempted rape and robbery) that were pending against me?" I reasoned and questioned, "Could it have been that he knew that I had a very good chance of beating these cases or could it be possible that he and Mr. Hayes were wary of the fact that Atty. Bozo Jr. was attempting to represent me?"

As the evidence would eventually reveal itself later on, I came to the realization that it was the latter.

CHAPTER 26

Transported to the Big House (Prison)

I spent several more months at the rehab, before I was finally transported to prison in June 1980. I was transported and temporarily assigned for evaluation. Newly arrived prisoners were first sent to the Goree Unit for diagnostic evaluation, and then thirty days later prisoners will be assigned to different prison units throughout the state of Texas. I had only seen pictures of prison facilities in books, magazines, and on television. And on those occasions, prison didn't appear to be that ominous. However, from a real-life point of view, prison definitely was ominous and gave an aura of hell (if your mind could grasp what hell might feel like) being on earth.

I was placed in a cell with two other prisoners. We were confined three men to one cell. The cell only had two bunks, and one person would have to sleep on the floor. So when I was offered the top bunk by my cellmates, I felt that I had been really fortunate to gain two very nice cellmates. However, when nighttime came around and I climbed on the top bunk for some relaxation and sleep, I came to the understanding as to why my cellmates had been so forthwith in giving me the top bunk. It was hot as hell on that top bunk. As a matter of fact during June 1980 and the subsequent months that followed, it had been the hottest in the last twenty-five years in the state of Texas. Temperatures were reaching 125 degrees on certain days. I felt that I now knew what hell really did feel like.

SILENCED BUT DETERMINED

I stayed at the Goree Unit for thirty days, and then I was transported to the Coffield Unit in Tennessee Colony, Texas. This unit housed mostly prisoners that were in my age bracket. I was now going through the transition of becoming adjusted to the place where I would be living for the new decade or so. (At least that's what I thought.)

Once I was assigned to my cell, I settled in. I was informed by my cellmate (Walker) that inmates are allowed out of their cells for recreation (watching TV, lifting weights, playing basketball, playing dominoes and other table games) from 6:00 p.m. to 10:00 p.m., Mondays through Thursdays; from 6:00 p.m. to 1:00 a.m. on Fridays; from 8:00 a.m. to 1:00 a.m. on Saturdays; and from 8:00 a.m. to 10:00 p.m. on Sundays.

My first couple of days I just stayed in my cell and did a lot of thinking. My cellmate was an old-school cat (meaning, he had been in the penitentiary for quite some time, ten years to be exact). Walker gave me knowledge about the dos and don'ts of prison life. And he was a very cordial individual. He told me that he mostly spent his time gambling, boxing, working in the fields (picking cotton, pulling up okra, pulling up weeds, cutting down trees, and picking corn), and exercising. He also told me that I needed to start coming out of that cell. He said, "This will be the only way for you to start feeling comfortable." He said, "I experienced the same thing that you are going through when I first came to prison." He had a fifty-year sentence, and he had already came up for parole, which had been denied.

On the fourth day of my stay at the Coffield Unit, I began going to the dayroom (where inmates congregated outside their cells). The dayroom was a small area built in the front part of a wing (where inmates lived). The dayroom had concrete and steel tables, a TV, two big windows, and it was encircled with concrete and steel bars. There were about thirty-five to forty loud inmates in the dayroom during recreation time. And it was so hot in the dayrooms to the point of being almost unbearable. I don't believe that anyone wore a shirt during those extremely hot summer months. I stayed close to Walker, who was at the domino table gambling for money on a daily basis.

I was a very good domino player myself, and I realized that this could be a source of income for me later on in the future. A number of the other inmates were sitting on wooden benches watching TV. For the life of me, I couldn't understand how they could hear the TV with all the noise going on. Later I would come to realize that a person would eventually get used to it all.

Other inmates were telling stories to their homies (most people from the same city, neighborhood, and/or association in crimes in the past) about their pimping and having-money days. Over at one table were two inmates who were reading books. One of the inmates was vehemently explaining something to the other inmate. I proceeded to walk closer, so I could see what type of books they were reading. The books were law books. Upon seeing the law books, I immediately became interested. I walked back over to the domino table, and I asked my cellmate what was the deal on those two guys sitting at that table reading law books. He told me that this one guy who was sitting on the left side of the table was a writ writer (someone who writes writs, petitions that are filed in criminal and civil courts) and he also studied the law. He stated that the inmate on the right side of the table was being helped by the other inmate. My cellmate told me that the writ writer enjoyed helping other inmates with their criminal cases. My cellmate also told me that the dude who was known as the writ writer was a really cool dude. He stated, "If I wanted to, I should just walk over to him and talk to him."

I walked over to the table where the two inmates were sitting and I introduced myself. I said, "Hi. How are you fellows doing? My name is McQueen." (Everyone in prison usually identified themselves by their last name only.) The writ writer introduced himself as King, and the other inmate said his name was Moore. I told the inmates that I had recently arrived on the unit and that Walker was my cellmate. Additionally, I informed them that Walker said it would be cool to come over to talk to them. (In prison, that's one of the main violations with inmates, to invade their very small space).

King stated, "Yeah, man, it's cool, have a seat." He said, "I was just explaining the Texas criminal rules of procedure to Mr. Moore."

At the steel and concrete table where King and Moore were sitting were four wooden seats. I took a seat on one of the wooden seats. I took a seat right next to inmate King. I intently listened as King was explaining to Moore what should have been done in his case, but what hadn't been done by his attorney. This conversation continued for about an hour. Finally, Moore told King that he understood everything and whatever he couldn't understand he would get with him tomorrow. Moore said that he was going to go back to his cell and go to sleep, because he was tired from working hard all that day.

King then began focusing his attention on me. He said, "So what's up, man? Do you enjoy listening to people talk about the law?"

I said, "Yes, I do."

He said, "Well, you sound as though you are another brother who has been messed over by our supposedly fair and equal criminal justice system."

I said, "That's exactly the case."

He said, "Let me tell you something. On an average day, I come in contact with ten or more inmates who say that the court system has shafted them in one way or the other. Either it's the fact that they were innocent, but found guilty or that they received too much time for the crime(s) they committed. You wouldn't believe the stories that I hear all the time. Regardless of what I just mentioned, I don't mind spending my time trying to help someone. Actually, helping people gives me the opportunity to acquire more knowledge of the law." He said, "I usually don't get into asking people about their crimes and what they were convicted of. So if you just want to talk about the areas of law that you feel you were denied, we can do this."

I told King that I didn't know that much about the law to be speaking about specifics. However, I told him that I do know that I was denied a fair trial and that I am positive that my court-appointed attorney acted with the prosecution in convicting me and ensuring that I receive a forty-year sentence.

King said, "So you have a forty-year sentence?"

I responded, "Yes, I do."

He asked me, "Is it aggravated?"

I stated yes.

King said, "Did you know that you must serve one-third of your time before you will be considered for parole?"

I responded yes.

He then said, "And it is not a definite fact that you will make parole once you are considered."

I looked at him while my mind digested his last statement. I had not known this information. I had been under the impression that once I had served thirteen calendar years and four months of my sentence that I would be certainly be released on parole after serving all this time.

I conveyed this much to King. King told me, "It is not a guarantee that you will make parole once you are considered for parole." He said, "This decision is strictly left to the discretion of the parole board. So the best thing for you to do is try and stay out of trouble, go to school, work, and obey the rules to enhance your chances of making parole."

I told King that I had no intentions of being locked up for almost fourteen years with just a hope that I will eventually make parole. King asked me, "So what are your *plans*, do you intend on trying to escape, or do you intend on giving your time back?" I told him that I am hoping that I will be able to someway or somehow eventually give back my time. King asked, "And how are you going to accomplish this task?" I told him that I am intending on learning the law and hopefully go back to court and regain my freedom. I explained to King that prior to my coming to prison I would study the law with this old-school cat by the name of Dan. I informed him that Dan was very knowledgeable with the law.

I further explained that Dan had told me that I had some good claims for a reversal. King said, "Let me tell Dan who you are talking about." He asked me, "Who is this guy name Dan, that you are talking about?"

I told him that I had met Dan in the rehab in Harris County.

He said, "Well, I don't believe that I know him, and really that is beside the point." He said, "The point that I am about to make to you is that it is not easy to undo a criminal conviction. Regardless if

it's a valid or invalid conviction." He added, "As a matter of fact, a criminal conviction is very hard to get a new trial on. However, it's not impossible, so let me hear about your case and I'll give you my opinion."

I told King everything about my case, from the meetings that I had with Mr. Hayes, my meetings with the police detectives, my appearance at the lineups, my evading arrest, the testimony of Mrs. Peters, Mrs. Malveaux's testimony, the testimony of the Houston Police Department chemist and forensic evidence, the testimony of the doctor who had examined the victim, my court-appointed attorney convincing me to waive my right to a jury trial, the final sentencing stage, where I was denied assessment of punishment hearing, the fact that my attorney and the prosecutor had told the visiting judge that Judge Guyon had already assessed the forty-year sentence when in fact I had not been before Judge Guyon, since back on December 19, 1979 (guilt and innocence stages), how I had attempted to obtain the services of another counsel to represent me on the remaining charges, and finally how subsequently after I had met with this attorney, the prosecutor dismissed the charges. I vehemently stated to him that I was innocent.

King asked me a few specific questions pertaining to my waiving my right to a jury trial, my witness not being subpoenaed by my attorney, the assessment of punishment proceedings, and my appeal. Specifically, King asked, "What did your attorney say was a beneficial reason to you for you to waive your right to a jury trial and allow yourself to be tried before the judge?"

I told him that my attorney told me that he had known this judge and should I possibly be found guilty he could possibly get me a probated sentence. King said, "That's absurd, because aggravated rape does not carry a probated sentence."

I said, "Yes, I now know this, plus considering the fact that I was always already on a four-year probation for the unauthorized use of a motor vehicle."

King asked me, "What was the deal about your attorney not subpoenaing your witness?"

I told him that Ms. Knoxson was my only witness, and she had been with me on July 30 or 31 when I was assaulted by two guys who beat me with an aluminum bat, causing me to suffer scars, and bruises, whereas I subsequently had to wear bandages for several weeks after the assault.

I further explained that during the time that Mrs. Peters said that she had been raped (letting him know the date was August 9) those scars and/or bruises were still visible on my face, and the fact that Mrs. Peters testified that her attacker bore no visible physical scars or bruises. I further informed King that I had wanted to use Ms. Knoxson's testimony to impeach the identification testimony of Mrs. Peters.

Additionally, I informed him that Ms. Knoxson was at my home with me and our daughter on the morning of September 27, the date that Mrs. Malveaux had said that I had attempted to rob and rape her. King said, "This is the same lady that you recognized as someone you had gone to high school with you."

I said yes.

He said, "But I thought that this case was dismissed."

I said, "Yes, it was, however, Mrs. Malveaux testified in the rape case, because her and her husband were responsible for my being arrested and subsequently placed in a lineup."

He asked me, "So what you are saying is that your attorney did not subpoena your witness even though you requested that he do so."

I said, "Yes, that's right. After my trial, I spoke with Ms. Knoxson over the telephone, and she told me that she did not know the date of my trial, nor did she ever receive a subpoena. However, over a month prior to my trial, Ms. Knoxson received a telephone call from Mr. Hayes's secretary and she asked Ms. Knoxson if she would be willing to testify at my trial, and Ms. Knoxson told her that she would be willing to testify."

King asked, "Did the secretary ask her or tell her what she was supposed to be testifying to?"

I said no.

King said, "So as I understand it, after you were found guilty by this judge, a Judge Guyon, right? Your attorney made a request that a

presentence investigation report be conducted and the judge granted this request?"

I stated yes.

"And then your court proceeding was adjourned for thirty days with the intent to assess your punishment at the end of the thirty days."

I said, "That's right."

He stated, "And at the end of the thirty days, you were summoned back to court, but you didn't go back before the judge, because he was supposedly sick."

I said yes to his inquiry.

He then stated, "You then went back to court on two or three other occasions, but on each occasion the assessment of punishment was rescheduled, because Judge Guyon wasn't there."

"That's also correct," I said.

He stated, "But on March 14, you were taken before a visiting judge, a Judge Patterson, who said that the prosecutor and your attorney had told him that Judge Guyon had already assessed your punishment at five to forty years' confinement and the proceedings before Judge Patterson was the final sentencing stage."

I stated, "That's also correct."

King said, "Man, you did get shafted, however, the assessment of punishment and the presentence investigation hearings should have been made a part of the record and these proceedings should be transcribed. Tell me about your appeal?"

I said, "Well, it's like I told you, I wasn't in the courtroom after I was sentenced, because I was escorted back to the county jail. But when I went back to court for an appearance on the two remaining cases, Mr. Hayes at that time informed me that he had requested an appeal in my case and the fact that the judge appointed Mr. Hayes to represent me on my appeal."

King said, "It's almost rack time [meaning, time to go to our cells for the rest of the night], but first thing you need to do is get that lawyer off your case, and I will show you tomorrow how to go about doing this." King told me to come to the dayroom first thing tomorrow evening.

Back inside my cell, I immediately laid down and began doing a lot of thinking. My cellmate said, "I saw you and King engaged in a lot of conversation, is he going to help you?"

I told him that he was going to help me get my court-appointed attorney off my case, but that's all he has said that he was going to do for now.

Walker said, "That dude is good with the law, I heard that he already knew the law before he got locked up, I even heard that he represented himself at his trial." He went on to say, "What's really impressive about him is that he is still young, the cat is only twenty-one years old, and around here you don't see people his age getting into the law." Then he asked me, "How old are you?"

I told him that I was twenty-two years old.

He said, "Man, you two are a perfect match."

I told Walker that I was going to try and get some sleep, because I was exhausted and tired.

He said, "Okay, I'll see you at breakfast."

At around 6:00 p.m., I met King in the dayroom at what was going to become our usual spot. King got straight to the point. He said, "Last night, I did a lot of thinking about the things that you told me pertaining to your case. For one thing, I sincerely hope that you were honest with me about everything that you told me."

I told him that I was honest.

He then said, "Well, I have never, during my time being associated with lawyers, judges, clerks, prosecutors, the various courts, and studying law, have I heard or read about a person being deprived of a fair and impartial trial in the manner you explained to me." He said, "Your case seems like a fairy tale, something a person will read about in a book. I am positive that your attorney was working with the prosecutor to get an easy conviction. However, there is one thing that I believe that you need to be really concerned about and that is, your attorney and the prosecutor doing something to cover up their tracks in this case." He said, "I wouldn't even be surprised if they had destroyed some of your trial records, because I can't see how your conviction will stand on appeal." He asked me, "Do you have any family or friends that will pay for you a lawyer?"

I told him, "No, that's why I didn't have a lawyer during my original trial. My only option was the court-appointed attorney."

He said, "Well, looks as though you are going to have to do this on your own."

I told him that I didn't mind, but I would appreciate it if he would help me out. He told me that he would help me, but he said that within the next month or so he was expecting to go back to court on his case.

I told him that I understood, and I asked him how much money he was going to charge me to help me. He said, "My thrill is just helping people beat these no-good criminals." He said, "Believe this, lawyers, judges, and prosecutors are criminals just like the people they send to prisons." Later on during my journey of studying the law, I would realize just how true this statement really was.

King told me that I needed to immediately file a motion to dismiss my attorney on appeal. He also said that I should also file a motion with the court for another attorney to represent me on appeal. Additionally, he told me that I should file a motion requesting a copy of the trial transcript and statement of facts, so he and I could search for grounds of error to file in my appeal.

He showed me how to prepare and write up all the motions. He asked me if I had the postage to mail out the motions. I told King that I had some money in my prison trust fund account; however, at the very minute I didn't have any stamps or any writ envelopes to mail out the motions. King supplied me with the stamps and three writ envelopes, which were necessary items for me to be able to mail out the three motions. He told me to just pay him back for the stamps and writ envelopes whenever I get those items from commissary.

It only took us a few hours to complete all the motions. I mailed the motions (motion to appoint counsel on appeal and motion for a copy of the transcript and/or statement of facts) to the Harris County Trial Court clerk, Atty. Hayes, and Prosecutor Chris Lorenzo the very next morning (July 1980).

King told me that the next few weeks, he would be showing me how to study and learn all the different twists to the law. King stated, "Law has a gray area, whereas some people have a different

interpretation than what other people reviewing the same type of law may have."

The very next day, myself and King were at our mutual meeting place. On numerous occasions, a few other inmates would come by and show their legal documents to King and/or ask for his advice on certain things. He would always make sure that I was aware of what the documents were and what the legality of the conversations were. King began telling all the other inmates that I was his assistant. He said that I was very smart and I picked up on many things very quickly.

He also said that my ability to discern certain aspects and facts pertaining to the law was very important and would go a long way in my being able to regain my freedom.

For several weeks, King taught me what he said was the in-depth processes of the law. I realized that his teachings were different from that of old man Dan's. I told him so. He said, "Dan was the typical prison inmate who thought that he knew the law, when in fact he did not."

He said that Dan had taught me the surface aspects of the law, something he said was very easy for anyone to pick up and turn around and pride themselves as someone who really knew the law. He said that he was going to teach me all that I needed to know about the law, which would put me on the scale with someone who had attended law school.

For the first time, I asked him how he became so knowledgeable about the law. He told me that he had gained knowledge of the law while he was in law school briefly. He said that he had worked as a paralegal for a law firm prior to his arrest. He stated that he had rubbed elbows with many judges, lawyers, clerks, and politicians while he was employed in Austin, Texas. He said, "This is how I know firsthand just how corrupted these officials really are."

King told me that he had been convicted of two murders, where he was subsequently sentenced to life in prison on each case. He said, "I can't see myself doing twenty years before I am even considered for parole. I will definitely give my time back, I bet my life on it."

I said to him, "Can't you possibly get someone like one of the lawyers that you know or work for to help you with your case?"

He told me, "For one thing, I don't trust lawyers," and then he added, "For another thing I rubbed a few people the wrong way with my honesty when I was working for these mafia types."

I asked him were the people that he worked for were really mafia types. He said, "No, but that's what they acted like and that's the way they carried themselves. And if you didn't play according to their rules, you were out on your head." King told me that he had represented himself during his trial. He said that he had been convicted and sentenced almost two years ago. His appeal had been affirmed, but he currently had pending in the state court a petition for writ of habeas corpus. He went on to say that he was only waiting to go back to court for an evidentiary hearing. I didn't have any knowledge as to what a writ of habeas corpus and an evidentiary hearing were.

I asked him if he was innocent of the crimes, and he told me that he was. He said that it was self-defense, two against one. He told me that he had a wife and a son. He then asked me if I was married and had any children. I told him that I was not married, but I did have three daughters.

He said, "Man, all girls? How old are they?"

I told him that my oldest daughter, Jessica, was three years old, and my daughters Tammie and Ejama had recently turned one year old.

He said, "Yeah, man, you need to hurry up and get back out there."

I said, "Yeah, I know."

For a little over two months, we did a great job in regard to his teaching methods coupled with my ability to learn about many different aspects of the law. During this time, I hadn't heard anything from the court pertaining to my motions, which I had subsequently filed to the court on two other occasions.

Finally, one day, Mr. Hayes wrote to me and informed me that the trial court had denied my motion for a copy of the trial transcript. Additionally, he informed me that he was in the process of

completing my appellant brief. Mr. Hayes stated that as soon as he completes the appellant brief that he would send me a copy.

I subsequently showed this letter to King. He told me that I needed to get this lawyer off my case and I couldn't afford for him to represent me on appeal. He said, "That attorney will make sure that you don't get no action." He stated, "I can assure you of this." I asked King what else I could do. I told him that it appeared to me that the court would not dismiss Mr. Hayes from my appeal. King told me that he had an idea. He told me that I would need to file a lawsuit against Mr. Hayes for ineffective assistance of counsel and for conspiracy—for conspiring with the prosecutor to ensure that I would be convicted and sentenced to forty years in prison. He told me that he would show me exactly what I needed to do.

King asked me how much money I had on the books (meaning, inmate trust fund account where prison officials keep inmates' monies and then allow those inmates to withdraw this money to buy items out of the unit commissary). I told him that I had over $200. I asked him why he wanted to know this. He told me that the federal court, where I'll be filing my lawsuit would probably make me pay the filing fee; which was $165 or make me pay a partial filing fee determined by the court. He told me that I had to write the clerk of the court in the district that I had been convicted in. He then said that this would be the Southern District of Texas. He said that I needed to ask for three copies of 42 USC 1983 forms and two copies of the in forma pauperis forms (seeking indigent status). He said that he would get the address to the court the next day.

He explained to me that he believed that once I filed this lawsuit against Mr. Hayes that Mr. Hayes would willingly withdraw from my appeal as soon as he had been served with a copy of the lawsuit. He also explained to me that the federal courts are split on whether a person can bring a lawsuit against a private lawyer in a 1983 lawsuit. He said that it didn't really matter whether or not I would be able to win the lawsuit; my ultimate goal is to get Mr. Hayes to withdraw from representing me on appeal. I definitely agreed.

While I was waiting for the forms from the federal court, King told me that I needed to write my claims against Mr. Hayes on several blank sheets of paper.

He told me to just outline what Mr. Hayes didn't do and what he should have done at my trial. It took me several days to write this out and as soon as I completed this I showed it to him.

CHAPTER 27

First Challenge in Court

He said that the results of my work were very good, and he directed me on a few other important issues to allege. The next day, I had everything in complete order.

About nine days after I wrote my letter to the clerk of the Southern District Court, I received the 1983 and in forma pauperis forms that I had requested. King showed me how to complete these forms. Subsequently after I completed the forms, I mailed them off to the court. King explained to me that once the court reviewed my forms that the magistrate of the federal court will determine if I had to pay the entire filing fee or if I had to pay a partial filing fee. He further explained that once I paid the filing fee, the court's process server will serve a copy of my lawsuit to Mr. Hayes. King said then he would be compelled to answer the lawsuit within a certain period of time, which period of time would be ordered by the court. Finally, King said, "Things are now in motion."

About six days after I mailed the lawsuit against Mr. Hayes to the court, I received a copy of the appellant brief that Mr. Hayes had filed on my appeal with First District Court of Appeals in Houston, Texas. Subsequently after I received the brief, I immediately began reading it. That evening when I went to the dayroom, I gave the brief to King, so he could also read it.

Subsequently after King finished reading the brief, he said, "I knew that he was going to file a frivolous brief." He said, "Man, this does not have any merit, the only thing that he did was attack the legality of your arrest and you admitted at trial that you took off

running when Mrs. Malveaux's husband and the police told you to halt. So you don't have a legal claim to stand on by challenging the legality of your arrest."

He said, "Now I actually believe what you told me even more after reading this brief." He went on to say, "I also believe that your entire trial was a setup."

King said, "Well, now I need to explain to you about filing a supplemental brief in your behalf and how it is done." King showed me a copy of a supplemental brief where I could allege my claims that it would considered to be valid grounds for a reversal in my case. Additionally, he said, "This supplemental brief could be filed along with the brief that Mr. Hayes had previously filed on your appeal."

He asked me what I thought my grounds for reversal were. I told him that I thought that I had a good claim for ineffective assistance of counsel, unknowingly and involuntarily waiving my right to a jury trial based on the false information that I received from Atty. Hayes; that I had been denied the right to due process to a fair trial when the trial judge denied my requests (motion and verbal requests made in open court and motion for chemical analysis) to submit to blood and hair samples to be taken from me and matched with the clothing (dress, panties, and panty hose) and semen and foreign hairs found on the victim's clothing and prior tested to determine whether or not I was the rapist; and that I had been denied the right to due process, because I was not allowed to be present at the assessment of punishment and presentence investigation hearings.

King said, "That's good, it's just like I told you earlier, you are a fast learner." He then gave me a listing of several law books to research. He told me that I would need to find several cases to include with my arguments in my supplemental brief. He explained that I probably would not find any cases that were on direct point with my contentions, because to the best of his legal knowledge, what had happened to me during my trial, he hadn't never heard or read about this ever happening to anyone else before.

He said that I should just focus my attention on finding cases that support my contentions of ineffective assistance of counsel, a denial of due process to appear at my assessment of punishment

hearing, a denial of my right to have a jury trial, and a denial of due process to have exculpatory evidence submitted at my trial. He explained that the exculpatory evidence would have been the results of matching my blood and hair samples with that taken from the victim's clothing. I told him that I understood. He told me that he would help me, but that time was running out, because he was expecting on going back to court any day now.

About thirty days after I had mailed the lawsuit against Mr. Hayes to the Southern District Federal Court in Houston, Texas, I received an order from the court. The order informed me that I would be required to pay a $40 filing fee, and $3 for the federal marshal to serve a copy of the lawsuit to Mr. Hayes.

I wrote to my father, and I asked him to send a money order to the clerk of the Southern District Federal Court. I also provided him with the case number of the court. My father took care of this matter for me. In three weeks' time, subsequently after I had asked my father to pay the partial filing fee and process server fee, I received an order from the court ordering that a copy of my lawsuit be served to Atty. Hayes, and Mr. Hayes was ordered by the Court to *answer* the lawsuit within thirty days after receipt thereof.

A week after I received the court's order, I received a copy of a motion to withdraw as counsel on appeal from Mr. Hayes. Mr. Hayes had filed the motion with the 232^{nd} Judicial Court (court where I had been convicted and sentenced). Mr. Hayes requested in his motion that he be allowed to withdraw as my counsel on appeal. The motion reflected that it had been *granted*. However, there was no judge's signature on the motion. Later on while studying the law, I found out that the district court, 232^{nd}, Harris County, Texas, where I was convicted was without jurisdiction to rule on Mr. Hayes's motion to withdraw. The review and subsequent granting of this motion would have to be accomplished by the appeals court.

Several months passed by, and I continued to study the law with King's assistance. However, I was becoming more knowledgeable with many different aspects of the law, and I sought out his assistance less. Plus I was preparing myself to handle this matter on

my own, because I knew that King would be leaving sometime in the very near future.

My father was expressing that he was becoming more and worried about me. He told me that he had contacted a family member who was a lawyer and asked the family member to take my case. My father told me that this relative told him that my case was a federal case and he could not help me. My father was disabled, and he could not afford to hire an attorney for me. In February 1981, I asked my father to purchase a copy of my trial transcript and statement of facts from my trial. The costs of these documents was $255. My father purchased all the documents and sent all of the documents too me.

I informed King that I had finally received a copy of my trial records. He told me that he wanted to take a couple nights off from doing anything else, so he could read the entire trial records. I asked him when he wanted to do this. He said tonight, if I didn't mind. I told him that I didn't have a problem with that. I subsequently gave him my trial records, so he could read them.

After King completed reading my trial records, he told me this. "Yeah, man, I can now really see for myself that you really did get shafted, this record doesn't reflect as being a fair and impartial trial." He also told me, "You recall the conversation that you told me that you had with Judge Patterson at the final sentencing stage of your trial. I responded, "Yes, I do."

He said, "Well, this conversation hasn't been made a part of the record."

I asked King to let me read the portion of the record that he was speaking about. He directed me to the part of the record where myself, Mr. Hayes, and the prosecutor were before *Judge Patterson during the* final sentencing stage. And any conversation with Judge Patterson pertaining to my witness not being present, my theory about the bruises and/or scars being on my face when the victim was assaulted were not in the record, nor was my informing Judge Patterson that Judge Guyon had not previously assessed my punishment, and the fact that I had not been back into the court since I had been found guilty back in December 19, 1979, was also not in the record.

I asked King, "Why isn't this conversation a part of my record?"

He said, "It's just like I had figured, for these people to be able to get away with what they had done to you during your trial, they would have to cover their tracks. And this is the way for them to do it."

I said, "But, man, how can they leave out important parts of the record?"

King said, "Easy, all they have to do is just make sure that the court reporter doesn't include this part of the record when she prepares and completes the record, and this is exactly what she did." He additionally said, "This is probably the main reason that Mr. Hayes made sure that he was appointed your attorney on appeal."

Some years later after I thought about King's last statement pertaining to Mr. Hayes making sure that he was appointed my attorney on appeal, so what had transpired in my trial could be concealed, I came to the realization that this was exactly true. Surely, Mr. Hayes had to know that I did not want him representing me on appeal after I had attempted to have Atty. Bozo Jr. represented me in the two remaining cases pertaining to Mrs. Malveaux. Additionally, along with the statements that I had to Judge Patterson at the final sentencing stage pertaining to Mr. Hayes not subpoenaing my witness and the fact that I had not been present during the assessment of punishment and presentence investigation hearings.

I asked King, "So the court reporter is down with it too?"

He said, "It wouldn't surprise me not one bit. This is just the way these people operate."

King said, "There is something else also."

I said, "What?"

He said, "There is no transcribed record of presentence investigation and assessment of punishment hearings being conducted."

I asked, "Well, shouldn't this help me in proving my claims that I was never present during the presentence investigation and assessment of punishment hearings?"

He said, "Yes, this should help you." He went on to say, "But I can see where they also made an attempt to further cover their tracks." He showed me the docket sheet, and he said, "Do you see this?" He was showing me where the following "Defendant appeared

with counsel at the assessment of punishment hearing on February 14, 1980 in open court" was stamped in red ink on the docket sheet. King said, "This is how they intend to get away with this mockery of justice."

I said, "Just by this sentence being stamped in red ink on the docket sheet is enough to deny my claim."

King said, "There is a law entitled the presumption of regularity, and this means that whatever is stamped on the trial records is presumed to be true, unless a person can show otherwise and prove that it is not."

I asked him, "How can I prove that this part of the record is not true?"

He told me that he hadn't ever seen anyone be able to do it before, but I would need to really research the law and see if I could find a case that would give me some direction.

King informed me that I could start off by arguing that if in fact the assessment of punishment and presentence investigation hearings had taken place, this would be transcribed in the statement of facts just like the testimony of the trial and the transcribed portion of the final sentencing stage.

I asked King what he meant by this statement. He asked me was I aware of the fact that this testimony used in my trial had been transcribed, so whoever was reading the statement of facts would know what was said during my trial. I told him that I knew what he meant by that. He then said, "The final sentencing stage of your trial was done the same way." He again showed me that portion of the final sentencing stage where myself, Mr. Hayes, and the prosecutor were talking to Judge Patterson. I said, "Okay, now I understand."

King handed me my trial records, and he told me that I should immediately read the entire record and let him know if I find something else not in the trial records, but should have been.

CHAPTER 28

New Attorney on Appeal

The next day after my conversation with King, I received a letter from an attorney by the name of Charles Melder. Mr. Melder had informed me that he had been appointed as my attorney on appeal. Additionally, he stated that he was in the process of reviewing copies of my trial record to determine whether or not there were any meritorious grounds for relief to raise on appeal. He informed me that he would be filing a brief in my behalf.

I subsequently showed King this letter. He told me to not be too optimistic about this new attorney until I could actually find out what he is about and what type of claims he will argue in my behalf. He said "Remember, he is court appointed also." King told me that I should file a complaint with the State Bar of Texas against Mr. Hayes.

He gave me the address, and he told me to just explain exactly what it was that Mr. Hayes did during my trial that ensured your conviction. He said, "State everything that you and I have talked about these last several months." The next morning King left on the chain bus going back to court. I never saw or heard from him again.

Without King around to help me or at least be my security blanket, I became despondent. However, I eventually came to realize that if I was going to get out of prison and vindicate myself that I would have to continue fighting. For some strange unknown reason, I was hoping that Atty. Melder would be the one to help me. I therefore wrote Mr. Melder a letter, and I informed him of the claims that I thought were reversible errors in my case, which would entitle me to a new trial. I asked that he include these errors in any brief that he

may file. I also informed him that my trial counsel had messed me over and I sincerely hoped that he wouldn't do the same. I informed him that I had just filed a civil action lawsuit against my previous attorney for messing me over.

Mr. Melder never did respond to my letters. I wrote additional letters; however, he never responded. I eventually filed my complaint against Mr. Hayes with the State Bar of Texas. And I had begun putting together my supplemental brief to file in my appeal. While I was doing this, I had been informed that my appeal had been moved from the Court of Criminal Appeals in Austin, Texas, to the First District Appeals Court in Houston, Texas. However, my appeal was again transferred from the First District Court of Appeals in Houston to the Tenth Court of Appeals in Waco, Texas.

I eventually wrote a letter to the staff counsel for inmates (a small group of individuals paid by the state of Texas to aide inmates with certain types of legal issues), and I asked for someone's assistance in helping me in getting in contact with Mr. Melder, so I can find out whether or not he filed a brief in my behalf. In response to my letter, I was informed that I would be having an interview very soon with someone from the staff counsel for inmates.

As time passed by, I had become to get very good at understanding of the law. I was almost certain that my legal claims had merit, and I would eventually get my case over turned on appeal. Several weeks after I had wrote to the staff counsel for inmates, I was called to this secluded area on the unit, where this young white guy was waiting for me. He introduced himself as Calvin Warren.

He asked me to have a seat. Subsequently after I had a seat, he asked me why I needed the assistance of the staff counsel for inmates. I explained to him my situation pertaining to the fact that my initial attorney on appeal, a Mr. Hayes, had withdrawn from my appeal and now a Mr. Charles Melder was handling my appeal. I informed him that I had received one correspondence from Mr. Melder, and he had not responded to any of my other letters that I had wrote to him. I told Mr. Warren that I needed to find out whether or not Mr. Melder had filed a brief in my behalf and if he had planned on sending a copy of this brief to me. Mr. Warren told me that he could

call Mr. Melder for me and make inquiry as to whether or not he has in fact filed a brief in my behalf. And if he had, he would ask him to forward a copy of that brief to me. I told him that I would appreciate this, if he could do this for me. I thereafter gave him Mr. Melder's telephone number.

Three weeks later, I was summoned for another interview with Mr. Warren. Mr. Warren told me that he had spoken to Mr. Melder, and Mr. Melder informed him that he had in fact filed a brief in my behalf. However, Mr. Warren said that when he informed Mr. Melder that I had wanted a copy of the brief, Mr. Melder said that he wasn't going to send me a copy. Mr. Warren said that he informed Mr. Melder that I was entitled to a copy of the brief, but Mr. Melder had vehemently refused to provide me with a copy.

Mr. Warren said that he would contact Mr. Melder again in about a week and again make another request that he send me a copy of the brief. He said that this was all he could do for me. I asked him if I had any other options to make Mr. Melder send me a copy of the brief. Mr. Warren told me that I could file a complaint with the State Bar of Texas and/or I could write to the court and seek the court's intervention. I told him that I would do both, and I again thanked him for his assistance. He told me that he would write to me and tell me what Mr. Melder had said.

Later I filed a complaint with the State Bar of Texas against Mr. Melder for his refusal to provide me with a copy of appellant brief, and I additionally wrote to the 232nd District judge and requested that the court instruct Mr. Melder to send me a copy of the appellant brief. I never received a response back from the court.

Two weeks after my second visit with Mr. Warren, I received a letter from Mr. Warren. In this letter Mr. Warren informed me that he had again spoken to Mr. Melder, and again Mr. Melder had refused to send me a copy of the brief. Mr. Warren informed me that he was closing my file, because there wasn't anything else that he could do for me.

The actions of Mr. Melder were very strange to say the very least. However, the way that other things that had preceded, the events with Mr. Melder had gone I guess that I should have expected this.

King had previously told me not to become faithful in this attorney. Sometime later when I eventually found out that Mr. Melder had not filed a brief in my behalf on my appeal, it appeared as though he had mysteriously disappeared. I made several attempts to contact his office, and I found out that he was no longer there. And I also searched the legal directory for his name and address. But no one by the name of Mr. Charles Melder was practicing law in Houston, Texas.

CHAPTER 29

My Supplemental Brief on Appeal

In June 1981, I submitted my supplemental brief to the Tenth Court of Appeals, Waco, Texas. I was very proud of the manner that I had done my brief. I felt very confident that if the court of appeals reviewed my brief, I would be getting a new trial very soon. I argued ineffective assistance of my trial counsel, the denial of due process to appear at my assessment of punishment hearing, and the denial of due process by the trial court by refusing my requests to take blood and hair samples from me, so these samples could be matched with the seminal and foreign hair samples taken from the victim's clothing. Now all I had to do was wait.

I sort of got away from studying the law. Before I completed and filed my supplemental brief, studying the law was a ritual for me. When I got up in the morning, until the time I went to bed late at night. But now I was into pouring my energy into other things. I was now into my second semester in college, and I was also attending typing school. I was spending a lot of my evenings on the domino table trying to make a dollar.

Months passed without hearing anything from the court of appeals. Most people that I had talked to pertaining to the court taking so long to rule on my case were telling me that this was a good sign. Many of the other guys would say that the longer the court took to rule, the better my chances were getting a reversal. However, in February 1982, I became a little too impatient, so I decided to

go ahead and write to the court of appeals and find out the status of my case. In response to my letter to the clerk of the Tenth Court of Appeals, I was informed that the court had already ruled on my case back on December 10, 1981.

Enclosed with the clerk's letter was a copy of the court's opinion. In that opinion, the court only ruled on the two frivolous claims filed by Mr. Hayes. This ruling was to affirm my conviction. The court concluded that I was not entitled to hybrid representation; therefore, the court did not even consider my supplemental brief. I was devastated.

This is when I found out that Mr. Melder had never filed a brief in my behalf with the court of appeals. At least the court did not mention anything about any claims raised in my behalf by Mr. Melder. One thing that continued to invade my mind was the fact that all these people (judges, prosecutors, court-appointed attorneys, court reporter, and appeals court judges) were conspiring against me to ensure that I continued to stay locked up.

For the life of me, I could not figure out why these judges did not review and rule on my supplement brief. I mean, anyone could see (that is anyone who was knowledgeable of the law) that the claims raised by Mr. Hayes in his brief were frivolous and totally without merit.

Furthermore, for a case as serious as *mine was*, it would definitely seem as though the judges of the court of appeals would want to make sure that I had been given a fair trial and would be making their decision based on the fact that I didn't receive a fair and impartial trial.

But no, these judges were only satisfied with making a ruling that would totally disallow my best legal presentation before the court. I was not entitled to hybrid representation (meaning that I was not entitled to represent myself on appeal when I already had an attorney representing me) was the court's (Tenth Court of Appeals in Waco, Texas) ruling pertaining to my supplemental brief.

Regardless of the fact that I had raised several meritorious issues for reversal. And the reality of it all was that Mr. Hayes had not represented me on appeal. I had not been notified of the court's decision,

no one had filed a motion for rehearing in my case, nor had anyone filed a petition for discretionary review to the court of criminal appeals seeking additional review of my case. It all was beyond unfair. But as time went on, I would become accustomed to being treated unfairly.

After discussing my options with several other writ writers, I was informed that it was too late to file a motion for rehearing with the court of appeals. Additionally, I was informed that the time period for filing a petition for discretionary review with the Court of Criminal Appeals had expired. I was informed by the other inmate(s) of my remaining options, which was to file a writ of habeas corpus in the 232nd District Court (where I was convicted).

I languished around for several months not doing very much of anything in the way of fighting my case. I continued to spend the majority of my time going to college and typing school. Plus, going to school was a way for me to get out of working. Before I knew it, 1982 was almost gone. I had been moved from one wing at the prison (Coffield Unit in Tennessee Colony, Texas) to another wing. Once I was moved to F wing, I met this older guy by the name of Robert Williams. Robert Williams was known as a writ writer (title for someone studying and operating a legal assistance to inmates). I would pass by his cell and see him with law books stacked as high as the ceiling. And whenever he was out of his cell he would say that he had to get back to his cell in a hurry, because he was working on his criminal case and a lawsuit that he had filed against the Houston Police Department.

Eventually I got around to knowing Mr. Williams. He was a con artist by trade and a very outgoing person. So my becoming acquainted with him wasn't very hard to do. Once myself and Mr. Williams became more acquainted, he began telling me about his criminal case and his civil case, which he said that he was suing the police department for unlawfully taking over $100,000 from his possessions. I found Mr. Williams as being very articulate and intriguing guy. He showed me pictures of his lovely family and his newly purchased home and car. Mr. Williams fit the description of a person that was not supposed to be behind bars. That is, if such a person exists.

My conversation with Mr. Williams eventually turned to my conviction and what had occurred at my trial, after my trial, and with my appeal. Mr. Williams asked me what I was now doing to further challenge my conviction. I told him nothing at the moment, but several people had informed me that I could file a writ of habeas corpus and further challenge my conviction.

Mr. Williams told me that this was correct. He asked me, "Do you plan on doing anything else on your case?"

I told him, "Yes, but right now I am so despondent after what had happened with my appeal that I didn't have any more faith in the court system."

Mr. Williams told me that this was a natural response to what I had previously endured. Mr. Williams told me that if everything that I had previously told him about my case was the truth and there was no doubt that he could get a reversal of my case within six months to a year. I told him that I had a copy of my entire trial records, that is, the parts that were not intentionally omitted. He said, "Good, if you'd like, I'll check out your trial records and tell you what I think."

I told Mr. Williams that I already had a good idea as to what my grounds of error would be. I would just probably need for him to correctly make the appropriate arguments and additionally prepare the writ. He said that he would check out the records and get with me.

About a week later, Mr. Williams told me that I had several good claims for reversal, but he said that he was positive that the trial judge's refusal to allow me to submit to blood and hair samples to be matched with that of the seminal stains and foreign hair samples taken from the victim's clothing was an obvious reversal. He went on to explain that in a rape case it is very hard for the prosecution to meet all the elements of a rape being committed. He said that the only evidence that they had against me was that of the victim who stated that she had only seen my face for a couple of seconds at the most. He said, "This, coupled with the fact no weapon was ever found and the fact that it didn't appear that anyone from the police department ever attempted to locate a weapon from you, and the fact that the victim did not have the opportunity to view you in a lineup until almost two after the crime was committed were all the

more compelling reason(s) to allow you to take the hair and blood test samplings."

Mr. Williams informed me that he would take my case, but he would require a fee for his services. I asked him, "What would you charge me?"

He said, "I want and need a typewriter."

I said, "Man, a typewriter costs almost $200."

He said, "It costs exactly $165."

I told him that I didn't know whether or not I could come up with that type of money.

Mr. Williams said, "It doesn't have to be brand-new, I just want a serviceable typewriter."

Just so happened a few days prior to my conversation with Mr. Williams, another inmate had approached me about him wanting to sell his typewriter, which was almost new. I informed Mr. Williams about this inmate, and he told me that he already knew about it. He said, "This is the typewriter that I want." The inmate with the typewriter wanted $100 in commissary for the typewriter. This actually wasn't no big problem for me, because I had been doing a lot of winning on the domino table, on football boards, and betting on basketball games. So I basically had almost or even more than $200 worth of commissary in my cell at that very moment.

However, if Mr. Williams wanted a brand-new typewriter from the commissary, then this would mean that I would have had to pay the money out of my prison account and I didn't want to spend what little money that I had in my prison account.

It was becoming obvious to me that I would be in prison for a long time coming. The next day I spoke with the inmate who had the typewriter, and we agreed on a price of $100 and the type of commissary items that he wanted. That evening I gave him his $100 in commissary and he gave me the typewriter. To make the matter administratively legal for transfer of ownership to Mr. Williams, I paid this inmate that worked as a bookkeeper to make the necessary arrangements to have the proper paperwork completed, authorizing Mr. Williams as the owner of the typewriter. Once this was accom-

plished, I gave Mr. Williams the typewriter. He immediately began working on my case.

It became obvious to me that I did not have much of a chance in having my case properly heard in the courts without some type of assistance. I did not know of an attorney that would assist me free of charge. However, I came up with the idea that if I could somehow get some type of media attention on my case that I could possibly get lucky and some attorney might end up reading about my case and subsequently volunteer his/her services.

CHAPTER 30

Writing Many Letters Seeking Help

I began my journey by getting in contact with the media by writing to a number of radio and television stations, and then to a number of newspaper companies. I wrote to the following: newspapers—the *Advocate, Houston Community Newspaper Inc., Houston Chronicle, Houston Defender, Houston Forward Times, Houston Informer, Houston Post, Houston Sun*; radio stations—KPFT-AM 90.1, KPRC-AM 950, KTRH-AM 740, KTSU-FM 90.9, and KYOK-AM 1590; television stations—KHOU-TV Channel 11, KPRC-TV Channel 2, and KTRH-TV Channel 13. All in the Houston area. I additionally wrote letters to the *Texas Monthly, Newsweek,* and *Time* magazines on numerous occasions.

 I wrote at least five communications to each of the above aforementioned entities. In my initial letter to each entity I explained how things had occurred in my criminal trial and how in my attempts to have my case overturned, jurists have ignored the fact that I had been deprived of a fair and impartial trial. I only received a response from the *Texas Monthly* magazine, which informed me that their magazine was not catered to writing articles like I had described.

 To forward each communication to each of the above aforementioned entities at least on five different occasions took about nine months. My waiting period was about one year and a half. Subsequently after not receiving any response within that time period, I came to realize that help and/or even any interest would

not be coming my way. Another feeling of hope had disappeared without any positive results.

For some unknown reason other than desperation, I decided to address a correspondence to John B. Holmes Jr., head district attorney for Harris County, Houston, Texas. In my correspondence dated April 3, 1997, to Mr. Holmes Jr., I requested that an internal investigation be conducted of Assistant District Attorney Chris Lorenzo, the DA that oversaw the trial of my case; the court reporter who transcribed the testimony in my case and who was responsible for putting together the court records from my case; and my court-appointed attorney Ronald N. Hayes. Attached to my epistle was a copy of a sworn affidavit completed by me. In this affidavit I articulated facts from my trial consisting of fact that I believed that the assistant district attorney, the court reporter, and my court-appointed attorney had entered into a concerted conspiracy to ensure that I was convicted without the benefit of a fair and adequate trial. Additionally, I stated that these individuals collectively conspired to ensure that I would not be able to obtain any relief from my illegal conviction.

Specifically, I contended that my court-appointed attorney made sure that I did not receive a fair trial by committing the following acts: He did not subpoena my only witness (Ms. Pamela Knoxson) (see fig. 4) to testify in my behalf. I stated that Mr. Hayes falsified documents in response to a habeas corpus that I had filed in 1993 stating via affidavit (see fig. 5 and fig. 6); the fact that he failed to present my defense before the court by demonstrating that at the time the victim was assaulted I had bore facial scars and/or bruises; he gave me false information (stating that he could possibly get me probation from the judge because he knew the judge) by convincing me to waive my right to a jury trial; Atty. Hayes stood by and did not say a word in regard to the falsification of my trial records; whereas those records (falsely stated) that I appeared with counsel on February 14, 1980, at the presentence investigation and the assessment of punishment hearings. I stated to District Attorney Holmes that this proceeding never took place, that is, while I was present in the courtroom. Additionally, I stated to Mr. Holmes that my court-appointed attorney Ronald N. Hayes filed a frivolous brief

on my appeal, which basically did not have any chance of overturning my conviction.

I further contended in my correspondence to Mr. Holmes Jr. that the assistant district attorney was present when Mr. Hayes convinced me to waive my constitutional right to a jury trial and he heard Mr. Hayes tell me that if I should waive my right to a jury trial and should I get convicted, he could possibly be able to get me probation, when in fact I wasn't even eligible for probation, because I was currently on probation at the time that I had been charged with the crime. I continued to state that the assistant district attorney stood by without saying a word in regard to the records reflecting that I was present during the assessment of punishment and the hearing on presentence investigation report. I contended no such proceedings ever took place and the documents had been falsified to say that these records did in fact exist. I vehemently contended in my letter that on the date of my final sentencing, which was conducted on March 14, 1980, before visiting judge (Judge Patterson). Judge Patterson stated that he was final sentencing me to five to forty years' confinement in prison, which Judge Patterson said my punishment had already been assessed by Judge Guyon. I further explained in my correspondence that during the final sentencing stage of my trial, I told Judge Patterson in open court that Judge Guyon never did assess my punishment. And the fact that when I conveyed this information to Judge Patterson, he informed me that the assistant district attorney and Mr. Hayes had already stipulated that Judge Guyon had in fact assessed my punishment on February 14, 1980, while I was present in the courtroom. The fact that the statement that I had made to Judge Patterson had not been transcribed in the record.

I continued to explain to District Attorney Holmes that it was quite a coincidence that I had received the five-to-forty-year sentence that the assistant district attorney had previously offered to me in a plea bargain agreement, which I had clearly rejected.

Finally, I informed Mr. Holmes Jr. that the court reporter who transcribed my trial had entered into this concerted conspiracy with Mr. Hayes and the assistant district attorney by unlawfully deleting my statements that I had made to Judge Patterson and she had falsi-

fied the docket sheet records by making a *stamped mark in red* stating "Defendant Appeared with Counsel on February 14, 1980, for the Assessment of Punishment Hearing" on this document.

I in turn mailed my letter and affidavit (contesting to the facts of that letter and my statements thereof) to District Attorney Holmes Jr. However, I never did receive a reply from District Attorney Holmes Jr. I also forwarded copies of the letter and affidavit that I had mailed to Mr. Holmes Jr. to the following people: United States Attorney Gaynelle G. Jones, Federal Building, Houston, Texas, whereas I requested an investigation into my allegations and I also requested that criminal charges be brought against Mr. Hayes, the assistant district attorney, and the court reporter; to Mrs. Shelia Jackson Lee, United States House of Representatives, Houston, Texas; Jack Loftis, editor, *Houston Chronicle* newspaper; and to the program director, KTRH-740 AM Radio Station, Houston, Texas, whereas I requested the assistance of these people in aiding me in convincing Mr. Holmes Jr. to conduct an internal investigation into my complaints. I did not receive one response to my communications from not one of those officials mentioned above. I additionally forward additional correspondences to the above aforementioned individuals seeking acknowledgment of receipt of my previous correspondences and affidavit. However, I still did not receive any response.

December 1997—I really felt that the door of opportunity to prove my innocence was on the verge of closing. However, as I had persevered in the past, I had once again come up with an idea that would open that door of opportunity once again.

During the year of 1996–'97, there were a number of organizations getting media print for assisting convicted persons who had previously claimed to be innocent of the crime that they were incarcerated for. I can't recall on television when I viewed a program about innocent people who have been wrongly and illegally convicted. There was this couple on the show who had been wrongly convicted for killing their daughter, when they had told everyone including the district attorney and the police that a dog had mauled their daughter to death.

Also on the same show was the situation pertaining to a woman who had claimed that an intruder had broken into her home and killed her children. She had already been convicted and sentenced to death for the murder of her own children. Speaking about her case was Joyce Ann Brown, who herself had been wrongly convicted where she had been incarcerated for nine years for a jewelry store robbery. She was able to eventually exonerate herself of all charges.

Joyce Ann Brown explained to Maury about this organization titled MASS INC. (Mothers/Fathers for the Advancement of Social Systems Inc.) that she was the founder / executive president of MASS INC. and they were dedicated to aiding those people convicted of a crime, but who had claimed that they were actually innocent of that crime?

Ms. Brown explained that the organization was in process of providing the lady on death row with legal assistance. After this particular show, I got the idea that I would get in contact with Mrs. Joyce Ann Brown and request legal assistance.

It took me about several weeks; nevertheless, I was able to get the address for MASS INC. I subsequently wrote a letter to MASS INC. explaining my situation and also requesting legal assistance. I received a response to my correspondence from Ms. Joyce Ann Brown herself, which was dated January 20, 1998. Enclosed with Ms. Brown's letter was an application form. I was instructed to complete the form and return it to Ms. Brown and MASS INC. The application form asked questions about my conviction, it also sought information about what led to my conviction and what I believed was relevant to support my claims of innocence.

This information was articulated in Ms. Brown's letter to me.

"Enclosed is an application form, if you are an inmate please fill it out and return to MASS, Inc. as soon possible. If you are writing on behalf of a love one, forward the enclosed application form to that person. The person incarcerated must fill out the form and return it to MASS, INC. This is not an acknowledgment of accepting your case, we will review your request and after careful consideration will respond. Please keep in mind that we are a small organization and our workers are volunteers, and it takes time to review cases. If there

was a chance that MASS, Inc. will be able to assist you, your application form will go into our active file. If your application enters into our active file, we ask that you please be patient. We do not have the staff, FINANCES, NOR TIME TO GIVE YOU AN UP TO DATE report on your case weekly. Once there has been progress, you will immediately be updated." "Regardless of the situation that you are requesting MASS, Inc. to help you with, we still need your application on file. This will help us to gather data that will show the areas in the system that need to be addressed."

I subsequently mailed the application with additional information back to Ms. Brown via certified mail. However, I never did receive any other response from Ms. Brown, nor from anyone else associated with MASS INC. pertaining to my request for legal assistance. I in fact forwarded at least ten to fifteen more letters to Ms. Brown seeking the status of my request for assistance. However, I never did receive any type of response.

Undaunted, I next forwarded a communication to a support group titled Impact. The newsletter describing Impact stated, "Impact! A 501(c) non Profit Organization was founded by Charles and Pauline Gladney, because of their personal experience and the recent heartbreaking challenge with the criminal justice system. This challenge began in May 1992, for Charles and Alice Barron and is currently pending an appeal from a January 1994, conviction to life in Texas Prison for Charles Barron." Group members joined together in an attempt to aid Mr. Charles Barron to overturn his illegal conviction and resulting life sentence.

The organization also indicated that it would provide assistance to other prisoners who had been illegally convicted as well. However, I never did receive any responses to my numerous letters to Impact, whereas I requested the assistance of that organization.

During this particular time period (1997–2000), a significant movement was taking place. Newspapers, magazines, television news, and radio news were presenting a wave of news pertaining to innocent people previously convicted of crimes that they didn't commit; they were now proving their innocence and/or were being provided with the opportunity to prove their innocence via DNA testing.

I once again seized this opportunity. I had finally come to believe that this would be a major breakthrough. Reason for my overwhelming optimism is that during my trial, the state introduced into evidence the victim's panties, panty hose, dress, and rape kit. Also testifying for the state was a police forensic expert. This expert testified that he had tested the victim's clothing (consisting of her panties, panty hose, and dress) and the contents of the rape kit, and he concluded that there were foreign hair and semen on the clothing that were not that of the victim. The forensic expert testified that the foreign hair and semen could have possibly came from the victim's attacker.

However, the state did not take any hair and blood samples from me to be matched with the foreign hair and semen taken from the victim's clothing. My attorney subsequently questioned the police forensic expert if it would be possible to match hair and blood samples taken from me and match with the foreign hair and semen taken from the victim.

Additionally, my attorney asked the forensic expert if there was no match of the samples taken from me and that taken from the victim would this possibly exclude me as the culprit of the crime. The forensic expert stated that if it was shown that the victim had not had sex with anyone else within a forty-eight-hour time frame and if the samples had not matched anyone that she had acknowledged having sex with, then it would be obvious that the foreign hair and semen stains came from the perpetrator of the crime, and if there was no match with the hair and blood taken from me that I could be excluded as the person who had committed this crime.

My attorney then asked me if I would be willing to submit to the taking of hair and blood samples from my body to be matched with the foreign hair and semen stains taken from the victim's clothing. I informed Mr. Hayes that I would be willing to submit to these tests as soon as possible, if it would help me in proving my innocence. Mr. Hayes thereafter filed a motion (after I insisted that he do so) with the court requesting that hair and blood samples be taken from my body for the purpose of being matched with the foreign hair and semen samples taken from the victim's clothing. Additionally,

while I was on the stand testifying, Mr. Hayes asked me if I would be willing to allow the state to take hair and blood samples from my body for the purpose of being matched with the evidence taken from the victim's clothing. I testified that I would allow this procedure to take place as soon as the state was prepared to do so.

Mr. Hayes at this time submitted his written motion to the court, requesting that the court allow the procedure. In a stunning ruling, Judge Guyon denied the motion and additionally denied my verbal request for the procedure.

By letter dated April 24, 2000, I contacted the law offices of Goldstein, Goldstein, and Hilley, San Antonio, Texas. Specifically, I contacted Atty. Cynthia Hujar Orr seeking the assistance of their organization. (Atty. Orr was associated with an organization that assisted innocent people who had been wrongly convicted to prove their innocence.) I asked Ms. Orr if her organization could help me in obtaining DNA testing for the purpose of proving my innocence. My communication dated May 26, 2000, a Loretta Sorensen reported for Atty. Orr. Ms. Sorensen articulated that currently in the legislature Senator Leahy and Representative Delahutt had previously proposed the Innocence Protection Act which would allow for the DNA testing similar to what I had been requesting. Additionally, Ms. Sorensen stated that currently under Texas law, she had encountered difficulty obtaining such testing (DNA), via post conviction, for individuals who have not filed writs of habeas corpus claiming constitutional violations with their convictions in addition to their claims of actual innocence. Finally, Ms. Sorensen stated that I would receive a more specific response in the near future.

I immediately responded to Ms. Sorensen's response. In my letter to Ms. Sorensen, I provided additional information, which was taken from a correspondence dated April 3, 1997, that I had previously written to John B. Holmes Jr., state district attorney, Harris County, Houston, Texas. In my correspondence to Ms. Sorensen, I articulated the fact that my conviction and resulting continued incarceration was the result of a conspiracy which was and continued to be carried out by my court-appointed attorney (trial attorney), the assistant district attorney (who prosecuted my case), and

the court reporter (who transcribed the records during my trial). I never did receive any other response from Atty. Orr, nor did I ever receive another response from Ms. Sorensen. I wrote an additional five to eight letters to Atty. Orr and Ms. Sorensen; however, I never did receive one response.

In July 2000, I prepared and mailed a motion titled request for DNA testing, and I requested the appointment of counsel to aid me in obtaining this DNA testing to Judge Mary Lou Keel, 232nd District Court, Houston, Texas, where I was convicted.

I articulated to Judge Keel I was seeking a DNA test in case number 303438. I reasoned in my request(s) that in 1979 I was illegally convicted of the crime of aggravated rape; the fact of the matter, during my trial, the prosecutor entered as evidence (the victim's panties, panty hose, clothing) (see fig. 2), whereas a forensic expert for the Houston Police Department Crime Lab testified that his examination discovered foreign hair and male semen were found on the victim's clothing. He furthered stated that a test could be conducted (whereby this test could determine whether or not I was the rapist in this crime). I further articulated to Judge Keel that during my trial my court-appointed attorney Ronald Hayes filed a motion titled motion for chemical analysis (requesting that such a test be conducted to allow the testing from those items taken from the victim and compared with my blood and hair samples) (see fig. 3) and the trial judge denied that motion, thereby depriving myself of the opportunity to prove my innocence.

Subsequently after forwarding Judge Keel several letters seeking ruling on my motion, a Stephanie Armand (title unlisted but she responded on Judge Keel's letterhead) responded and stated, "I have forwarded your letter to the Harris County Attorney's Office, so that they may look into this matter for you."

I subsequently wrote several letters to John B. Holmes Jr., Harris County district attorney, requesting that his office take action on my request for DNA testing. However, I never did receive any response from Mr. Holmes Jr.'s office.

CHAPTER 31

Seeking DNA Testing to Prove My Innocence

Early 2000, subsequently after receiving denial of several requests seeking DNA testing from the 232nd District Court, I subsequently submitted a letter to Texas senator Rodney Ellis seeking his assistance in getting DNA testing. In response, Senator Ellis forwarded me a letter (see fig. 7) dated June 20, 2000, indicating that he had recently proposed a criminal justice reform package with DNA testing inclusive.

By communication dated July 30, 2000, I sought the assistance of the Innocence Project (Benjamin N. Cardoza, School of Law, Yeshiva University, Brookdale Center, 55 Fifth Avenue, New York, Mr. Barry Scheck, director) in helping me to obtain DNA testing to prove my innocence. I received a postcard dated August 7, 2000, and I was informed that my letter whereas I requested assistance from the Innocence Project had been received.

In that letter I was informed that it would take at least 180 days or more before I would receive a response from their organization. Additionally, I was informed not to call and/or contact the organization again for any other reason. They said that they would contact me.

By communication dated May 16, 2001, Director Scheck wrote to me informing me that the Innocence Project provided pro bono legal assistance to convicted prisoners whose innocence can be demonstrated through DNA testing. Enclosed with Mr. Scheck's let-

ter was a questionnaire. Mr. Scheck instructed to complete the questionnaire and return it upon completion.

Additionally, Mr. Scheck informed me that I should be patient and refrain from writing or calling to inquire about the status of my case, that they will contact me as soon as possible after they have evaluated my case.

I subsequently completed (listing information pertaining to my conviction and innocence) the questionnaire and returned it via certified mail back to the Innocence Project. I never did receive any other response from the Innocence Project.

In August 2000, I forwarded a communication to Centurion Ministries, Princeton, New Jersey. Centurion Ministries also had an Innocence Project that aided convicted (innocent) people to prove their innocence via DNA testing. I received a response dated September 18, 2000, from Mr. James C. McCloskey, director/founder. Mr. McCloskey informed me that due to a lack of administrative staff, their organization had been forced temporarily to halt consideration of any new requests for their assistance. Therefore, their organization could not assist me.

The Texas media was reporting that the Texas legislature was in the process of passing a bill that would allow DNA testing, which in turn would allow convicted innocent person(s) to prove their innocence. This bill (titled Senate Bill 3) was passed by the legislature in 2001.

I subsequently forwarded the following documents: motions requesting to have DNA testing performed on my blood, affidavit in support of my motion, affidavit and leave to proceed in forma pauperis, and an alternative request seeking a time reduction of my current sentence to Judge Mary Lou Keel with a correspondence dated June 8, 2001.

By correspondence dated July 25, 2001 (Document D), Atty. Robert notified me that he had been appointed by Judge Keel to represent me pertaining to my request for DNA testing. Specifically, Atty. Alexander informed me that he was in the process of reviewing the district attorney's files to determine what evidence from my trial was still available, which would allow DNA testing to be conducted.

By correspondence dated November 6, 2001 (see fig. 8), Atty. Alexander informed me that two persons working in HPD (Houston Police Department) Crime Lab, James Bolding *employed* as a criminologist of the HPD Crime Lab, submitted an affidavit (see fig. 9) sworn to on September 12, 2001. Mr. Karl McGinnis, employed as a supervisor for the HPD Property Division, submitted an affidavit sworn to dated September 25, 2001.

Specifically, Mr. James Bolding, criminalist, HPD Crime Lab, and Mr. Karl McGinnis, supervisor for the HPD Property Room, stated in their affidavits that no evidence was ever tagged in HPD Incident Report #P-80813, which was the incident report number for the crime of aggravate rape, the crime that I was convicted of.

Additionally, a Ms. Melchora Vasquez, exhibits clerk for the Harris County District Clerk's Office, stated in her affidavit (see fig. 10) that no evidence (subsequently after my trial) from my trial had been filed with the clerk's office in case number 303438, which was the case number that I had been convicted under.

I subsequently forwarded a correspondence dated November 6, 2001, to Atty. Alexander. Specifically, I asked Atty. Alexander whether there were any other place(s) where evidence from my trial could be available.

I also asked Atty. Alexander to find out from the HPD Crime Lab official, HPD Property Room official, and the exhibits clerk who submitted affidavits, the name(s) of those official(s) who were responsible for filing and tagging evidence with HPD Crime Lab and Property Room, including the exhibits with the district clerk's office.

By correspondence dated November 14, 2001, Atty. Alexander asked me if there were any other clues concerning the evidence or if there were any other avenues to pursue.

By correspondence dated February 24, 2002 (see fig. 11), Atty. Alexander informed me that the state had filed a proposed *finding of fact* (see fig. 12) etc. with the court stating that no evidence (see fig. 13) was available for the purpose of DNA testing, therefore my request for DNA testing should be denied.

Additionally, Atty. Alexander stated that the trial court held a brief hearing on January 18, 2002, thereby subsequently granting the state's proposed finding of fact.

I thereafter forwarded correspondences dated March 5 and April 25, 2002, to Mr. James Bolding, criminalist, HPD Crime Lab, and Mr. Karl McGinnis, supervisor for the HPD Property Room, seeking information as to the name(s) of the official(s) who were responsible for ensuring that evidence from my trial was filed and properly tagged in HPD Incident Report #P-80813. These officials never did respond as to what department and/or official is responsible for ensuring that the exhibits accumulated during a criminal trial is properly submitted to the district clerk's office for filing and warehousing. I never did receive any response to my communication(s).

I then forwarded communications dated April 1 and April 30, 2002, to Charles Bacarisse, Harris County district clerk, seeking information as to whether or not exhibits were filed in case number 303438, subsequently after my criminal trial. Additionally, I requested information as to the name of the court reporter who worked for the 232nd District Court (court where I was convicted and sentenced) during the time of my conviction and sentence.

I received a communication dated July 23, 2002, from the district clerk providing me with the following information. No exhibits were filed in case number 303438 with the district clerk's office subsequently after my trial, the court reporter was responsible for making sure that the evidence and/or exhibits admitted during trial were filed with the district clerk's office for boxing and warehousing, and the name of the court reporter was Brenda Palmer during the time frame that I was convicted and sentenced.

Even though my opportunity to prove my innocence via DNA testing had been denied to me, I came up with another idea that would give me a fighting chance. However, I must admit that the events surrounding the denial of my request for DNA testing did not surprise me the least bit. I had figured that the state's district attorney office and possibly others would come up with some type of impediment to have my claim denied.

My next idea was a good idea from the legal viewpoint. However, I knew that faith had to be totally on my side for me to be able to obtain a fair review of these particular claims. And up until this point, faith had been on my mind and in my heart, but it had not been on my side.

Once again, I prepared and filed a habeas corpus (case number 303438-H). This application was filed by the Harris County district clerk on November 1, 2002. In this application, I sought relief from my illegal conviction based on two facts. I had been deprived of the opportunity to present exculpatory evidence to prove my innocence in violation of the *United States Const. Amendments V and XIV and Tex. Const. Art. I* section 19, resulting from the failure of the HPD police officials to properly file and tag the evidence in my case and the failure of the court reporter to properly file the evidence and/or exhibits from my trial with the district clerk's office, so this evidence could be boxed and warehoused with the clerk's office.

Additionally, I claimed as an alternative that I should be allowed an out-of-time appeal to file and reargue my appeal, as my first appeal of right, due to the fact that the court reporter from my trial never did file the evidence and /or exhibits from my trial with the district clerk's office.

The court of appeals, Waco, Texas, never did have all the evidence from my trial to be able to make a clear and effective ruling on the legality of criminal trial. It should be noted that during my first appeal before the court of appeals in Waco, Texas, I filed a supplemental brief in my behalf seeking to have my conviction overturned.

In one of my grounds for relief, I complained that I had been deprived of a fair trial, as a result of Judge Guyon's ruling denying my counsel's written and my verbal request to allow the state to take blood and hair samples from my body, so these samples could be matched with the foreign hair and semen stains taken from the victim's clothing.

By correspondence dated December 13, 2002, I was informed by the district clerk that enclosed was a copy of the state's proposed *finding of fact*, etc. that had been filed and adopted by the court. Relying on this *finding of fact* and *conclusion of law*, the court contended that

I had failed to state in my habeas corpus that I had availed myself of the statutory right to appeal the trial court's denial of DNA testing under article 64.05 of the Code of Criminal Procedure. Additionally, the court articulated that I was attempting to utilize article 11.07 to litigate matters which should have been raised on appeal. Basically, what the court was saying was that I had an avenue via appeal from the court's denial of my request for DNA testing. However, I did not agree with this ruling, because my attorney (Robert Alexander who represented me during the DNA proceedings) informed me that since no evidence from my trial was available for testing, this was the end of the road. And based on my knowledge of the statute which allowed DNA testing I felt the same way. As per Texas law, my habeas corpus application was forwarded to the court of criminal appeals for review. The court of criminal appeals did not give any reason for the decision.

An obvious choice was available to me as a result of the court's latest ruling. I could go back in court via habeas corpus application arguing that I did not file an appeal from the court's denial of my request for DNA testing, due to ineffective assistance of my court-appointed counsel (Mr. Robert Alexander) who represented me before the court. And that's exactly what I did. I proceeded to file another application for habeas corpus relief, whereas I articulated that I had been denied the effective assistance of counsel.

I specifically contended that my court-appointed counsel who represented me during the DNA process had stated to me in his letter dated February 24, 2002, that since no evidence was available from my trial, the court had denied my request for DNA testing. Mr. Alexander also stated that this was the end of the road; there was no way he and I could challenge the evidence of the Houston Police Department officials and the exhibits clerk, who had submitted affidavits stating that there was no evidence available from my trial.

Additionally, I argued that I had also been precluded from filing an appeal, due to Mr. Alexander's notation informing me of the court's decision, subsequently after the thirty-day deadline for filing an appeal.

On May 30, 2003, I received the respondent's original answer to my habeas corpus from Mr. Jack Roady, assistant district attorney, Harris County, Houston, Texas. In Mr. Roady's original answer, Mr. Roady stated that my petition should be denied because I was challenging the fact that my court-appointed attorney at the DNA proceedings had provided ineffective assistance of counsel during his representation at the DNA hearing by failing to inform me of my right to appeal the denial of my request for DNA testing. Additionally, Mr. Roady stated that pursuant to article 11:07 of the Texas Code of Criminal Procedure Writ of Habeas Corpus, I could not challenge the legality of the DNA proceedings since those proceedings were not in regard to the legality of my conviction and/or punishment.

Actually, Mr. Roady was arguing that I could not challenge a claim of a denial of an appeal from the DNA proceedings due to the ineffective assistance of counsel allegation. Mr. Roady thereby submitted a document to the trial court (232nd District Court) titled "Respondent's Proposed Finding of Fact, Conclusions of Law, and Order." Mr. Roady submitted this document to Judge Keel requesting that the court adopt and sign the order denying my petition for relief.

On June 16, 2003, I received another copy of the "Respondent's Proposed Finding of Fact, Conclusions of Law, and Order" from the trial judge Keel. Judge Keel signed the order dated May 29, 2003, denying my petition for relief.

The latest denial of my petition did not surprise me at all. As a matter of fact, the constant refusals to deny me any relief was something that I had become very accustomed to. However, this act by the assistant district attorney Jack Roady and Judge Mary L. Keel exemplifies the constant abuse of authority by officials who supposedly carry out the duty to uphold the law.

In my petition, I cited three cases (Ex Parte Beck, 621 S.W.2d 811, Ex Parte Goodall, 632 S,W,2d 751, and Ex Parte McPherson, 32 S.W.3d 860) in support of my arguments, which had previously been ruled on by the Texas Court of Criminal Appeals (which is the highest state court in Texas that reviews appeals, petitions, and lower court rulings in criminal cases). In these prior rulings, the court of

criminal appeals granted each applicant an out-of-time appeal, resulting from ineffective assistance of their trial counsel and/or appellant counsel, resulting from the facts that those individuals mentioned above had each challenged their case, as I had done, by a petition for habeas corpus.

So I don't understand how Mr. Roady, assistant district attorney, and Judge Mary Lou Keel could have had an oversight to these previous court rulings.

Judge Keel ordered the district clerk to forward my petition and other documents to the Texas Court of Criminal Appeals for review and final disposition. Under Texas law, the Texas Court of Criminal Appeals has the final say on petitions for writ of habeas corpus filed with state courts in Texas.

During the month of May 2003, while I was reading the *Houston Chronicle* newspaper, I came upon an article telling about a guy who had been incarcerated, but his brother was actually the person who had committed the crime. Now his brother was coming forward and admitting his guilt in an attempt to help his brother gain his deserved freedom.

What really interested me about this article was the fact that the innocent fellow was being provided assistance by an organization called the Innocence Network, which was based at the University of Houston Law Center on the University of Houston campus. A professor David R. Dow is the director of the Innocence Network.

I subsequently forwarded a letter to Professor Dow briefly explaining my situation and additionally requesting legal assistance from the Innocence Network. I subsequently received a response dated July 23, 2002, from an S. Yeargin (title not listed) informing me that S. Yeargin was working with Professor Dow.

S. Yeargin informed me that they had received my letter dated May 13, 2002, whereas I had requested legal assistance from the Innocence Network. Enclosed with the letter was a copy of a questionnaire for me to fill out and return to the Innocence Network.

I completed the questionnaire and immediately returned the document to Professor Dow at the Innocence Network. Additionally, I also enclosed a letter consisting of several pages explaining details

about my criminal case, trial, and subsequent attempts to have my conviction overturned.

I specifically informed the officials of the Innocence Network that my conviction was the result of a well-concerted conspiracy by my court-appointed attorney, the assistant district attorney who tried my case, and the court reporter who prepared the documents from my trial. I additionally contended that this individual and maybe others had conspired to also ensure that I would not be able to obtain any relief from my illegal conviction.

Several months had passed, and I had not heard anything back from the Innocence Network. I began writing many letters to Professor Dow seeking information pertaining to the status of my request for legal assistance. However, I did not receive any other response from anyone from the Innocence Network. I then asked my cousin LaQuinta McQueen, who was on the outside, to make an attempt to get in contact with Professor Dow and/or anyone associated with the Innocence Network. I asked her to find out what was the status pertaining to my prior request for legal assistance.

In the month of February 2003, my cousin wrote to me and told me that she had unsuccessfully made numerous attempts to get in contact with Professor Dow and others from the Innocence Network via telephone. LaQuinta told me that she had left her telephone number asking that she be contacted by Professor Dow and/or anyone else associated with the Innocence Network. However, as of April 26, 2003, she still hasn't heard from anyone.

Beginning on April 7, 2003, I decided that I would forward a letter to Professor Dow each week for the next two months, hoping that I will eventually hear from him or someone associated with the Innocence Network.

CHAPTER 32

My Recovery from Back Surgery

Beginning in February 2003, I began my physical rehabilitation. I was confined to a small cell inside the infirmary. My rehabilitation consisted of having a long rubber device and using a stepper (device where you step up and down). Freedom was now in sight, not based on my winning my freedom, but based on the fact that my forty-year sentence was coming to an end.

My current release on mandatory supervision (mandatory supervision law in Texas mandates that a prisoner should be released from prison once his/her flat time, 23 years and 353 days for myself, combined with good time accumulated [16 years and 3 days in my case] would total my entire sentence [40 years]). Therefore, via Texas law the prison system had to release me. I say *reluctantly*. I never was *granted parole*. As a matter of fact, the Texas Parole Board denied me parole on ten different occasions (September 13, 2003, three days before my forty-sixth birthday). So I was even more determined to be walking out that prison door. I could not see myself leaving in a wheelchair.

In May 2003, I had progressed where I could step on and off the stepper twenty times nonstop. By June, I was stepping on the stepper fifty times twice a day. Beginning in July, I was allowed to walk on my walker outside the cell. I would use my walker to step on the stepper two hundred times three times a day. By August 2003, I was taking steps without the walker. I was doing one thousand

steps on the stepper, one hundred times three times a day. I would only take off on Sundays, where I would pray to my *higher power*. Beginning in September, I was taking significant steps without the walker. Occasionally, my legs would give out, so I needed something to lean on. During my process of rehabilitation, I would see a physician three times a week. On many occasions, he would say, "I haven't seen anything like it. By all indications you should not be walking."

I said, "I have your answer."

He said, "What is it?"

I said, "God almighty, he has a plan for me." I always believed that the hospital (Hendrick's Hospital in Abilene, Texas) where I received the surgery intentionally crippled me. I was a walking warrior prior to my back surgery. Many prison guards feared me due to my ability to fight at a very high level. I spent years training myself to become a lethal weapon.

On September 2, 2003, I was transported to a solitary holdover cell. There I could no longer do my exercising. I was restricted to improvise (survival in prison depends on the ability to improvise, remember, I'm talking murderers, rapists, robbers, people committing fraud, hitmen, drug dealers, and burglars) in order to continue my rehabilitation.

I would do two hundred squats while holding on the cell bars three times a day. I needed to strengthen my legs and quads. Additionally, I continued to use the rubber bands to give my legs and feet flexibility (my feet were like stone, and there was no rotation between my foot and ankle).

Due to the fact that I had been transferred from the prison infirmary and placed in solitary confinement via prison regulations, the prison officials should have had a hearing (classification) to determine why I was being held in a solitary confinement cell. However, on September 5, 2003, I stopped several of the guards and asked them to make inquiry as to why I was being held in a solitary cell (where the food was horrible in comparison to eating in the infirmary). Classification was always held in a room adjacent to the area where I was being held. On September 8, 2003, I spoke to a white guy named Mr. Springfellow. Mr. Springfellow informed me that he

was a classification member, and one of the guards had informed him that I needed to talk to someone.

I instructed Mr. Springfellow that I had been placed in a solitary confinement without a classification hearing. Additionally, I informed Mr. Springfellow that I was not being provided with the same opportunity to physical repair, via proper rehabilitation equipment, proper foods to eat, and the opportunity to be evaluated by a doctor. Now I could only see a nurse, and by the time it was documented and processed that I needed to see a doctor, I would be going home. However, the medications that I was on were no longer available. Finally, I expressed to Mr. Springfellow that I was supposed to go home on September 13, 2003. Mr. Springfellow informed me that he would take care of it and get back with me on that very same day. However, I never saw Mr. Springfellow on that particular day again.

On September 10, 2003, I received an inmate time sheet (which provides inmates with the flat time they served, the accumulations of good time and projected release date). My time sheet reflected that I had 23 years flat time and 350 days with no accumulations of good time. This time sheet reflected that my release date was in 2019.

Due to the fact that my cell was adjacent to where classification was being held, the very next day I beat on the walls until Mr. Springfellow came to my cell. I showed Mr. Springfellow the time sheet, and he informed me that he would check it out and get back with me. I informed Mr. Springfellow that I suggest strongly that he do just that because I said nobody is going to get away with playing my freedom.

CHAPTER 33

My Release from Prison

The very next morning I was transferred to the Walls Unit (facility where inmates are released). I was under the impression that I was going home in a few days from the Walls Unit. I therefore asked one of the guards if my paperwork reflected that I was going home. The guard informed me no, it did not; the paperwork indicated that I was being transferred to the Stiles Unit in Beaumont, Texas.

On September 11, 2003, I arrived at the Stiles Unit. Immediately myself and several other inmates who were just arriving at the Stiles Unit were taken before the Classification Committee. During my interview before the Classification Committee, I informed the five body members that I was supposed to be going home in two days on September 13, 2003. The chair of the committee, Ms. Price, stated that they didn't have anything before them reflecting that I was supposed to go home. However, Ms. Price said that they would check it out and get back with me the next day.

Around twelve o'clock in the afternoon, I still hadn't heard anything from the Classification Committee. I therefore walked to the Classification Committee hearing location and stood outside the entire day. Ms. Price was not available, and the other committee members didn't have an answer for me.

So I decided to patiently wait until the morning of September 13. Around 5:00 a.m., a prison guard working the block would notify people when they are on the chain, which arrived around 9:00 am. Once back at my cell I began packing up all my items (important documents, trial records, copies of past petition, and letters into

chain bags [red see-through bags inmates use when traveling from unit to unit and/or home]).

I couldn't sleep the entire night. I didn't know how to reach any of my family members. I was under the impression that I was being released to my oldest daughter, Jessica. Additionally, racing through my mind was the fact that these people were going to do something to interfere with my release.

Around 5:00 a.m., a young black guard came by walking down the catwalk informing those inmates who were leaving out on the chain. However, this youngest (Mr. Williams) passed by my cell. So as Mr. Williams was walking back, I asked him was my name on the chain list. He asked me what my name was and he looked on the list. He said, "No, man, I don't see your name." Then I informed him that I was supposed to be going home on this day. My mandatory release date!

Mr. Williams stated, "Sometimes they add people to the chain list." He further stated, "I will check it out and come back and let you know."

I told him, "Man, I would appreciate it, because I've been here almost twenty-four years and I can't allow these people to play with my freedom."

Mr. Williams stated, "Yeah, man, that's too long to be locked up." He further stated, "You deserve to go home." He said, "I will check it out and get back with you."

At around 6:00 a.m., Mr. Williams came back to my cell and he stated, "Pack it up, you're going home." I thanked Mr. Williams and began lining my chain bags by the cell door. I gave a bunch of commissary, books, and stamps to many of those remaining inmates. At 6:15 a.m., my cell door was opened, and I proudly walked out of that cell door. I was using a crutch to assist me with my walking. However, I was going home, so nothing else mattered.

Around 6:45 a.m., we loaded the white chain bus. At 7:00 a.m., we were heading to the Walls Unit, where I would be released. We arrived at the Walls Unit around 11:00 a.m. Subsequently after waiting about an hour, those of us who were being released were being processed back into the free world. I was given $50 and a pair of used pants and shirt. I wore my tennis shoes that I had purchased on the unit.

Prior to my release, a white lady by the name of Ms. Martin informed me that prior to my release, I was required to sign the release form, where certain stipulations were being placed on me. Subsequently after reading the stipulations, I indicated that I would not sign the form. Ms. Martin stated that this might affect my release. I told Ms. Martin that I didn't think so because the state of Texas was mandated by State Law to release me. I informed her that I was being released on Mandatory Supervision, not Parole.

Ms. Martin said that she would check it out and let me know. About thirty minutes later, Ms. Martin returned and instructed the guard to allow me to walk out the front gates of the prison, where I had spent the best years of my life.

In harmony with the great speech given by the Reverend Martin L. King Jr., I felt *free at last, thank God almighty, free at last.* At least that's what I thought. Stay tuned for my second book titled *Determined Revelation*.

My final thoughts. I have always asked myself the following questions listed below. How and why did this happen to me?

1. Why wasn't I ever taken before a magistrate judge and informed of the charges against me prior to indictment? However, this part of the process was absent for myself.
2. Why did my court-appointed attorney (Mr. R. Hayes) give me misleading information to convince me to waive my right to a jury trial? Thereby recommending that I have my trial before the trial judge (J. D. Guyon). I mean, common sense would indicate a trial by jury would be my best route based on the facts of this case.
3. Why did Judge J. D. Guyon *deny* my verbal and written motion(s) to be allowed to have hair and blood samples taken from myself to match that forensic evidence taken from the victim's clothing? The Houston Police Department forensic criminologist testified that he could conduct such a test and this test will be able to determine whether or not I was the rapist.
4. Why did Atty. Ronald Hayes fail to challenge the identification of the victim with the evidence that I had provided

to him, which would have created doubt in the victim's identification? Actually, this was my only defense.
5. Why did Atty. Ronald Hayes fail to call my only witness to testify as my alibi witness and my witness to challenge the victim's identification?
6. Why did Atty. Ronald Hayes file an affidavit with the court in response to one of my petitions falsely attesting to the fact that he did in fact subpoena my only witness, Ms. Pamela Knoxson? Mr. Hayes further gave false information under oath in his affidavit submitted to the trial court that not only did he subpoena my witness, but he also had her at my trial waiting to testify; however, he decided not to call her as a form of trial strategy.
7. Why did the Tenth Court of Appeals in Waco (subsequently after my case had been moved from two other appellant courts, Court of Criminal Appeals in Austin, Texas, and Fourteenth Court of Appeals in Houston, Texas) refuse to review my supplemental brief, where I had raised valid claims of ineffective assistance of counsel, denial of due process, and abuse of discretion of the trial judge J. D. Guyon by refusing my requests to have my blood and hair samples tested, which could have exonerated me back in 1979?
8. Based on the evidence and documentation, I contend that I had one of the worst trials in the United States history, not one appellant and/or federal court had provided me with a fair and impartial review of my contentions. Thereby reaffirming the unconstitutionality of those who acted with arbitrary actions during my trial and thereafter. Why?

I would like to end this story by surmising that those facts listed herein clearly demonstrate that I was *blackballed* by the American Judicial System.

The End

FIGURES

SYNNACHIA MCQUEEN JR.

Figure 1: Application for Subpoena for a State Witness

APPLICATION FOR SUBPO: A BY STATE FOR WITNESS IN .STRICT COURT.

No. 303437
303438
10/26/79 303439 LORENZEN

THE STATE OF TEXAS IN THE 232nd DISTRICT COURT
 Of Harris County, Texas

		OFFENSE	COUNT
vs. SYNNACHIA McQUEEN	DF NO.()	AGGRAVATED ROBBERY	
SYNNACHIA McQUEEN	DF NO.()	AGGRAVATED RAPE	
SYNNACHIA McQUEEN	DF NO.()	AGGRAVATED ROBBERY	

Please issue Subpoena_____in the above styled cause for the following named witness_____ residing in __Harris_____County, and whose exact location and avocation as far as known, I below state: AUDREY PETERS 6900 Bissonnet #519 & 6900 Bissonnet #74 Houston, Texas 77074

DR. FRANK KELLER C/O HERMANN HOSPITAL, 1203 ROSS STERLING, HOUSTON, TEX 77030
RE: CHART #78-32435-8
FLORA WILLIAMS C/O SHELTERING ARMS, 5304 Austin, Houston, Texas (524-2835)
JIM ZOTTER # 41596 C/o HPD LAB BRING L-79-5861
HOUSTON POLICE DEPT. OR#P-808013
T. W. VANYA #53465 P. K. JACKSON #47328
L. L. FULGHAM #41466 R. DELONY #45935
R. L. ROWELL #14017 C. M. NULL #56123

if to be found in your County, to be and appear before the Honorable__J. D. GUYON_____District Court in and for Harris County, on __MONDAY, DECEMBER 10__, 19_79_, at 8:45 a.m., to give evidence in behalf of the State and Defendant in a certain cause wherein the State of Texas is Plaintiff, and __SYNNACHIA McQUEEN__ is Defendant, and there to remain from day to day, and from term to term until discharged by the Court.

The Testimony of said witness_____is believed to be material to the State.

Chris Lorenzen
Assistant District Attorney
Harris County, Texas

OCT 29 1979

Sworn to and subscribed before me, this_____day of_____A. D. 19_____.

FILED
By_____
District Clerk
OCT 29 1979
Time 9:00
By _____ Deputy

RAY HARDY
DISTRICT CLERK
HARRIS COUNTY, TEXAS

By _____ Deputy

ORIGINAL STATE'S APPLICATION FOR SUBPOENA MICROFILM NO. F1543 2193

SILENCED BUT DETERMINED

Figure 2: Criminalistic Examination Sheet

175

SYNNACHIA MCQUEEN JR.

Figure 3: Motion for Chemical Analysis

No. 303,438

THE STATE OF TEXAS IN THE DISTRICT COURT OF

VS. HARRIS COUNTY, TEXAS

SYNNACHIA MCQUEEN 232ND JUDICIAL DISTRICT

MOTION FOR CHEMICAL
 ANALYSIS

TO THE HONORABLE JUDGE OF SAID COURT:

NOW COMES SYNNACHIA McQUEEN, the Defendant in the above entitled and numbered cause, by and through his Attorney of Record, RONALD N. HAYES, and files this his MOTION Requesting this Court to instruct the prosecution to have the Houston Police Department Laboratory conduct analysis of all items and substances taken from the Complainant, and for good cause would show this Honorable Court as follows:

to acquire said tests results and analyses.

III.

The Defendant further requests that such analyses derived at by the Houston Police Department Laboratory be made available to the prosecution, the Defendant and the Court.

WHEREFORE, PREMISES CONSIDERED, the Defendant prays that this Honorable Court instruct the prosecution to have the Houston Police Department Laboratory conduct all tests necessary on said items requested above and provide such results and analyses to the Court, the Defendant and prosecution.

RONALD N. HAYES, TBA# 092-80000
ATTORNEY FOR DEFENDANT
711 FANNIN, SUITE 800

ORDER

BE IT REMEMBERED that the foregoing motion was presented to this Court on the ___ day of December, 1979, and the Court, after considering said motion, is of the opinion that the motion should be GRANTED/DENIED, and it is, therefore

ORDERED that Defendant's motion for Chemical Analysis is GRANTED/~~DENIED~~.

[signature]
JUDGE PRESIDING

F1643 0911

SILENCED BUT DETERMINED

Figure 4: Application and Affidavit of Defendant

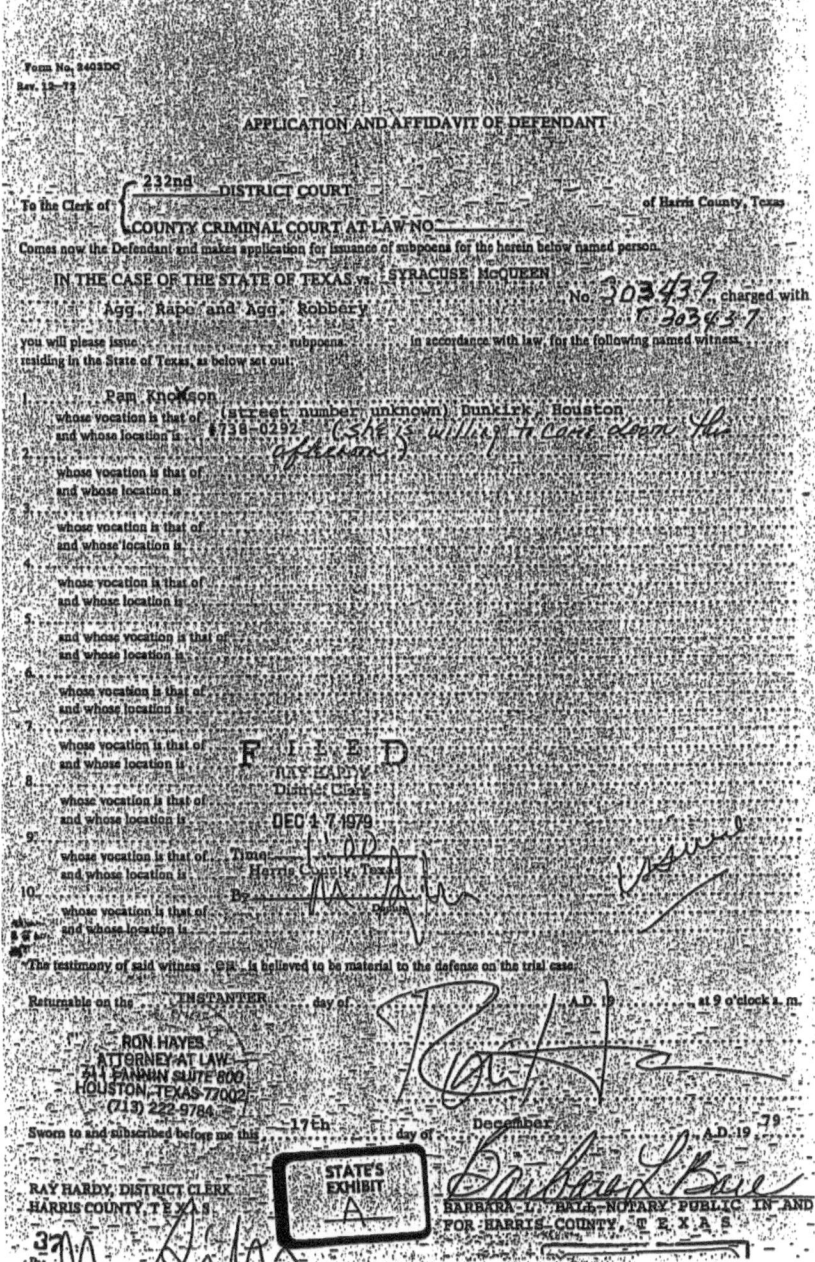

Figure 5: Affidavit of Atty. Ron Hayes

NO. 303438-D

EX PARTE	IN THE DISTRICT COURT OF
	HARRIS COUNTY, TEXAS
SYNNACHIA CARL McQUEEN, Applicant	232ND JUDICIAL DISTRICT

AFFIDAVIT OF ATTORNEY RON HAYES

STATE OF TEXAS
COUNTY OF HARRIS

BEFORE ME, the undersigned authority, on this day, personally appeared RON HAYES, who being duly sworn upon his oath did depose and say:

I subpoenaed Pamela Knoxson for Mr. McQueen's trial. My legal assistant, Barbara Ball, contacted Ms. Knoxson by phone to see if she would testify on Mr. McQueen's behalf. I had Ms. Knoxson available and willing to testify on the date of Mr. McQueen's trial, but I did not call Ms. Knoxson to testify as a matter of trial strategy. This was done with the express consent of Mr. McQueen. Ms. Knoxson did not testify because of my strategic decision not to call her, not because the court failed to compel Ms. Knoxson to appear, and was only done after consulting with Mr. McQueen.

I, Ron Hayes, state that the matters above are true and correct to the best of my knowledge.

FILED
KATHERINE TYRA
District Clerk

JUN 24 1993

Time: _____
Harris County, Texas
By _____ Deputy

RON HAYES

Figure 6: Respondent's Original Answer

NO. 303438-D

EX PARTE	§	IN THE 232ND DISTRICT COURT
	§	OF
SYMANCHIA CARL McQUEEN, Applicant	§	HARRIS COUNTY, T E X A S

RESPONDENT'S ORIGINAL ANSWER

Respondent, the State of Texas, through its Assistant District Attorney for Harris County, files this, its original answer in the above-captioned cause, having been served with an application for writ of habeas corpus pursuant to TEX. CODE CRIM. PROC. ANN. art. 11.07 § 2 (Vernon Supp. 1993), and would show the following:

I.

Applicant is confined pursuant to the judgment and sentence of the 232nd District Court of Harris County, Texas, in cause number 303438 ("the primary case"), where Applicant was convicted by the court for the felony offense of aggravated rape. The court assessed punishment at forty (40) years confinement in the Texas Department of Corrections[1].

The Tenth Court of Appeals affirmed the primary case in McQueen v. State, No. 10-81-116-CR, on December 10, 1981.

Applicant's previous applications for writ of habeas corpus, cause numbers 303483-A, 303483-B, and 303483-C were denied without written order on April 9, 1982, June 4, 1984, and October 9, 1984, respectively.

[1] Now the Texas Department of Criminal Justice, Institutional Division.

II.

Respondent denies the factual allegations made in the instant application, except those supported by official court records and offers the following additional reply:

REPLY TO APPLICANT'S SOLE GROUND FOR RELIEF

Applicant alleges that he was denied compulsory process for subpoenaing a witness. Specifically, Applicant claims that the court failed to issue a subpoena for Pamela Knoxson. However, a subpoena for Ms. Knoxson was applied for and issued.[2] Applicant's attorney had contacted Ms. Knoxson the day of trial, and had her available and ready to testify. Applicant's attorney made a strategic decision not to call Ms. Knoxson. It is trial counsel's prerogative, as a matter of trial strategy, to decide which witnesses to call and not that of the client. Weisinger v. State, 775 S.W.2d 424, 427 (Tex. App.—Houston [14th Dist.] 1989 pet. ref'd). Ms. Knoxson's failure to testify was a strategic decision by Applicant's attorney and not a failure of the court to compel her attendance. Accordingly, Applicant's sole ground for relief is without merit and should be denied.

III.

Respondent, however, requests that the Court find that there are controverted, previously unresolved facts material to the legality of Applicant's confinement which require further investigation by the Court. Respondent also requests that the Court

[2] A true and correct copy of the issued subpoena application for Pamela Knoxson is attached as State's Exhibit A and is incorporated herein for all purposes.

SILENCED BUT DETERMINED

designate the following as issues to be resolved in the above-captioned cause:

 1. whether Applicant was denied the right to compulsory process for obtaining a witness; and

 2. whether Applicant received a fair and impartial trial.

Respondent further requests the Court to order Applicant's counsel in the primary case, Ron Hayes, to file an affidavit summarizing the actions taken to represent Applicant and responding to the allegations that Applicant was denied compulsory process and a fair trial, as contained in the application.

<p align="center">IV.</p>

Service has been accomplished by sending a copy of this instrument to the following address:

 Mr. Symanchia Carl McQueen
 # 305897
 Hughes Unit
 Rt. 2, Box 4400
 Gatesville, Tx. 76597

SIGNED this 4th day of June, 1993.

FILED
KATHERINE TYRA
District Clerk

JUN 7 1993

Time: _____
Harris County, Texas
By _____ Deputy

Respectfully submitted,

Lynn Hardaway
LYNN HARDAWAY
Assistant District Attorney
Harris County, Texas
201 Fannin, Suite 200
Houston, Texas 77002
(713) 755-6657
Texas Bar I.D. #08948520

PREPARED BY:

Chad Bridges
CHAD BRIDGES
Legal Intern
Harris County, Texas

Figure 7: Letter from Senator Rodney Ellis

SILENCED BUT DETERMINED

Figure 8: Letter Dated November 6, 2001, from Atty. Alexander

<div style="text-align:center">
6002 MAXIE STREET

HOUSTON, TX 77007-3028

TEL. 713-863-1072

FAX. 713-862-9948

rfa2000@flash.net
</div>

November 6, 2001

Synnachia McQueen
Bill Clements Unit #305897
9601 Spur 591
Amarillo TX 79107

 RE: State v McQueen
 Cause No. 303438
 232nd District Court of Harris Co.
 Appeal (DNA testing)

Dear Mr. McQueen:

I just received your letter dated October 29, 2001.

The news so far is not good. I am enclosing three affidavits from persons working in the HPD Crime Lab, the HPD Property Room, and Harris County District Clerk. They report that they cannot locate any of the evidence from your trial.

I will order the record or what is left of it, review the DA's file and see if there are any other clues concerning the evidence or if there are any other avenues we can pursue.

This process may take longer than I originally estimated.

Sincerely,

Robert F. Alexander

RFA:jh
encl: Affidavits

SYNNACHIA MCQUEEN JR.

Figure 9: Affidavit from HPD Criminalist James Bolding

CAUSE # 0303438

AFFIDAVIT

THE STATE OF TEXAS

COUNTY OF HARRIS

Before me, the undersigned authority personally appeared, who being by me duly sworn, deposes and says:

My name is James Bolding. I am presently employed as a Criminalist for the Houston Police Department Crime Lab. I have reviewed the records within the Houston Police Department Crime Lab and found the following to be true:

The Houston Police Department Crime Lab does not show any record of having evidence tagged in Houston Police Department Incident #P-80813.

I have read the above statement and find it to be true and correct to the best of my knowledge.

Affiant: James Bolding

SWORN AND SUBSCRIBED before me pursuant to Texas Government Cord Section 602.002(7) on this the __12__ day of __SEPTEMBER__, 2001.

Notary Public in and for the State of Texas
Kenneth A. Hilleman
Houston Police Department
Homicide Division

Figure 10: Affidavit from Melchora Vasquez, Employed with the Harris County District Clerk's Office

Cause No. 303438

EX PARTE	§	IN THE 232ND DISTRICT COURT
	§	OF
SYNNACHIA MCQUEEN	§	HARRIS COUNTY, TEXAS

AFFIDAVIT

Before me, the undersigned authority, a Notary Public in and for Harris County, Texas, on this day personally appeared Melchora Vasquez, who being by me duly sworn, upon her oath deposes and says:

"My name is Melchora Vasquez. I have been employed by the Harris County District Clerk's Office since April, 1977. In 1984, I assumed the position of Exhibits Clerk in the District Clerk's Office. After a criminal trial, the Harris County District Clerk's Office takes custody of items which were admitted into evidence during trial, and the evidence is boxed and warehoused.

The records of the Harris County District Clerk's Office reflect that no exhibits were submitted to the District Clerk's Office from the trial of *Synnachia McQueen v. State of Texas* in cause number 303438.

I have read the above statement and find it to be true and correct to the best of my knowledge."

MELCHORA VASQUEZ
Affiant

SWORN AND SUBSCRIBED before me, under oath, on this the 9 day of August, 2001.

ANDREA LEWIS
Notary Public, State of Texas
My Commission Expires
JUNE 18, 2002.

NOTARY PUBLIC in and for the
State of Texas
My commission expires: _____

CLIENT COPY

SYNNACHIA MCQUEEN JR.

Figure 11: Letter from Atty. Alexander Dated February 24, 2002

<div align="center">
LAW OFFICE OF

ROBERT F. ALEXANDER

6002 MAXIE STREET

HOUSTON, TX 77007-3028

TEL. 713-863-1072

FAX. 713-862-9948

rfa2000@flash.net
</div>

February 24, 2002

Synnachia McQueen
Bill Clements Unit #305897
9601 Spur 591
Amarillo TX 79107

 RE: State v McQueen
 Cause No. 303438
 232nd District Court of Harris Co.
 Appeal (DNA testing)

Dear Mr. McQueen :

I'm afraid I have only bad news for you.

After checking in the only three places where evidence in your trial could be and not finding any, the Court held a brief hearing on January 18, 2002. I have enclosed the States' Proposed Findings of Fact, etc., which the Judge signed.

This seems to be a very raw deal for you because you had asked at trial for tests which were available then to be performed. However, without any evidence to test, this is the end of the road. You and I have no way of challenging these evidence custodians. There is no other remedy which the judge could fashion for you.

I agree it looks bad when the affidavits indicate that "no evidence was tagged in." Obviously, to have done a direct appeal, the 10th circuit would have needed a "complete record." But if the statement of facts reflects that the physical evidence was admitted into evidence, then that is enough for them to rule on your appeal.

Response To Your Earlier Letter:

1. I am returning the original newspaper article you sent me in January.

2. I read about your ad seg situation in one of your writs. Yes, it is completely irrelevant to this case. But I asked because one of my goals is to get you back out on the street as soon as possible. My opinion was that you had plenty of time to get paroled out and your ad seg

Synnachia McQueen - Page 2
February 24, 2002

situation explains why you're still there. I only wish you the best in your relations up there. I certainly believe it can be tough to follow all their rules and regulations.

3. I believe the district clerk is only expected to hold a statement of facts for about 5 years, unless it is a life sentence.

With this, I am closing your file.

Sincerely,

(signature)

Robert F. Alexander

RFA:jh

SYNNACHIA MCQUEEN JR.

Figure 12: State's Proposed Finding of Fact, Conclusions of Law, and Order

Cause No. 303438

STATE OF TEXAS	§	IN THE 232ND DISTRICT COURT
V.	§	OF
SYNNACHIA MCQUEEN, Applicant	§	HARRIS COUNTY, TEXAS

STATE'S PROPOSED FINDINGS OF FACT, CONCLUSIONS OF LAW, AND ORDER

Having considered the applicant's postconviction motion requesting DNA testing of evidence, pursuant to TEX. CODE-CRIM. PROC. art. 64.01, the State's motion requesting that DNA testing be denied, and the affidavits of Melchora Vasquez, James Bolding, and Karl McGinnis, the Court makes the following findings of fact:

FINDINGS OF FACT

1. On February 14, 1980, Synnachia McQueen, the applicant, was convicted for the felony offense of aggravated rape, cause number 303438, in the 232nd District Court of Harris County, Texas. Punishment was assessed at forty (40) years imprisonment in the Texas Department of Corrections – Institutional Division.

2. On August 27, 2001, counsel representing the applicant for purposes of the applicant's Article 64.01 motion filed a Postconviction Motion for Forensic DNA Testing in the instant cause.

3. The Court finds, based on the credible affidavit of Melchora Vasquez, Exhibits Clerk with the Harris County District Clerk's Office, that the records of the Harris County District Clerk's Office reflect that no exhibits were submitted to the District Clerk's Office in the instant cause. *See State's Motion Requesting Court to Deny DNA Testing*, affidavit of Melchora Vasquez.

SILENCED BUT DETERMINED

4. The Court finds, based on the credible affidavit of James Bolding, Criminalist for the Houston Police Department Crime Lab, that the Crime Lab does not show any record of having evidence tagged in the instant cause. *See State's Motion Requesting Court to Deny DNA Testing, affidavit of James Bolding.*

5. The Court finds, based on the credible affidavit of Karl McGinnis, Superivsor for the Houston Police Department Property Division, that the Property Room does not show any record of having evidence tagged in the instant cause. *See State's Motion Requesting Court to Deny DNA Testing, affidavit of Karl McGinnis.*

6. The Court finds that the applicant fails to meet the requirement of TEX. CODE CRIM. PROC. art. 64.03 (a)(1), showing that the evidence still exists and is in a condition making DNA testing possible.

7. The Court, based on the applicant's failure to meet the requirement of art. 64.03 (a)(1), finds in the negative the issues listed in 64.03 (a)(1).

8. The Court finds, based on the lack of evidence, that the applicant fails to show by a preponderance of the evidence that a reasonable probability exists that the applicant would not have been prosecuted or convicted if exculpatory results had been obtained through DNA testing.

9. The Court finds that the applicant fails to meet the requirement of TEX. CODE CRIM. PROC. art. 64.03 (a)(2), concerning his burden of proof.

CONCLUSION OF LAW

1. The Court, based on its negative finding of the issues listed in art. 64.03 (a)(1) and its finding that the applicant failed to meet the requirements of 64.03 (a)(2), **DENIES** the applicant's request for DNA testing in cause number 303438.

ORDER

THE CLERK IS **ORDERED** to send a copy of the Court's findings of fact denying DNA testing in cause number 303438 and the instant order to the applicant's counsel: Robert F.

SYNNACHIA MCQUEEN JR.

Alexander; 6002 Maxie Street; Houston, Texas 77007 and to the State: Lynn Hardaway; 1201 Franklin, Suite 600; Houston, Texas 77002.

BY THE FOLLOWING SIGNATURE, THE COURT ADOPTS THE STATE'S PROPOSED FINDINGS IN CAUSE NUMBER 303438.

SIGNED the ___ day of _____, 2002.

Presiding Judge
232nd District Court

Figure 13: Request for Post-Conviction DNA Testing

LAB # L79-5861 RW

Request for Post-Conviction DNA Testing

Date of Request __8/23/01__
Contact __K. Hilleman / Lt. Jett__ Agency __HPD__
Phone # __8-3642__

Incident # __Sexual Assault P80813__ Complainant __unk__
Date of Offense __8-9-79__ Defendant __McQueen__
Original Investigator/Submitting Officer __unkn__

Evidence in Volker boxes Yes ____ #(s) _____ No __X__

Microscope slides in lab Yes ____ No __X__

Other evidence in lab Yes ____ No ____

Evidence released to court Yes ____ Court # ____ No ____

Other disposition

Please attach copies of microfilmed reports

About the Author

Synnachia McQueen Jr. was raised in Houston, Texas, and born in 1957. He was a product of a systematic agenda designed to disenfranchise the black man. He was criminalized by a system that predicated itself on creating hardships on black men and women. Specifically, he speaks for the black man, because he has seen, witnessed, and experienced the injustice and resulting suffrage bestowed on a particular society of people. He sincerely believes that his story tells the story about the suffering of others as well. Truly many of us reject and turn a blind eye to a society being torn apart via power propelling on the piggyback of racial hatred. How fortunate it is that many of us are not unbeknownst to the disproportionate number of bland incidents, unjust murdering, mass incarceration, changing the course of generations of black people, destruction of the black family, and much, much more, all in response to the conspicuous racial hatred. The author has suffered tremendously from the injustice of the criminal justice system. So his book is to bring awareness to the many more people who suffer as he has mentioned herein. He hopes that his book becomes a voice for all of you who are *determined* to overcome your hindrance in life, due to the ignorance of man. *In God, believe.* He sends his message as an inspiration. *He truly believes* that *God* wants him to tell his testimony. Subsequently after spending 23 years and 353 days, he was released from prison and placed back into society. A society that had long forgotten about him. No one wants to hear the many nights that he called out from the many prison guards' beating. The cries that he made after he had gone on several hunger strikes (without that were gone unheard by many). The over one hundred media outlets that he wrote seeking assistance, his pleas fell on deaf ears. However wrong that was committed against him,

he tells about the many days and nights that he suffered from the prison guards' beating, the refusal to feed him on many occasions. The can in the hole where he had to defecate, determined as he is. He wrote this book. You be the judge. The many hunger strikes that he subjected himself to, hoping to bring about change against the racial practices of the prison system. Thirty-seven-plus years have been dedicated on his righting a truly unjust wrong.